Midkemia
THE CHRONICLES OF PUG

Map

- Iron Pass
- Northwarden
- Dencamp-on-the-Teeth
- ng Rush
- THE COUNTY OF CLAIRANCE
- Cavell Keep
- North Ox River
- THE COUNTY OF KLYDE
- THE COUNTY OF BLACKWOOD
- Rock Hollow
- Trapper's Camp
- Gre
- South Ox River
- Rodric's Deep
- Prank's Stone
- COUNTY VANDER
- COUNTY DONCASTER
- Lakeside
- Calinor R
- Rom Lake
- THE COUNTY OF THE SPIRES
- Miner's Camp
- The Pallasades
- THE COUNTY OF BLACKHEATH
- Granite
- COUNTY RIVER RUN
- River Cheam
- COUNTY CONHOWARD
- THE COUNTY OF THE FORELORN WOOD
- River Rom
- COUNTY STAGHORN
- Romney
- THE DUCHY OF TIBURN ON WILDE
- Tiburn
- THE COUNTY OF ROMNEY ON THE CHEAM
- Sloop
- COUNTY KEARY

RAYMOND E. FEIST
AND STEPHEN ABRAMS

Midkemia
THE CHRONICLES OF PUG

Harper Design
An Imprint of HarperCollins Publishers

HUDSON REGIONAL LIBRARY

The Grey Towers

WALINOR

MARGRAVES PORT

TULAN

HUSH

LAN

The Free Cities (ancient Bosania)

BORDON NATAL

PORT

PALENQUE

The Isle of O...

Straits of Darkness

LI MEOH

The Bitter

Dusky Wood

RANOM

Trollholm Mountains

OF MILES
60 70 80 90 100

Dedicated to the memory of
Tim LeSelle,
one of the original Thursday nighters. Never forgotten.

Contents

List of Characters .. 8

Introduction ... 12

Entry, the First ... 14

Section I: The Riftwar ... 16

Entry, the Second ... 23

Entry, the Third .. 38

Entry, the Fourth ... 44

Entry, the Fifth .. 54

Entry, the Sixth .. 66

Entry, the Seventh .. 74

Entry, the Eighth ... 88

Entry, the Ninth ... 104

Entry, the Tenth ... 132

Section II: Conclave, Darkwar, and Demonwar 138
Entry, the Eleventh 139
Entry, the Twelfth 156
Entry, the Thirteenth 165
Entry, the Fourteenth 171
Entry, the Fifteenth 181
Entry, the Sixteenth 185

Section III: Post Chaos Wars 194
Entry, the Seventeenth 197
Entry, the Eighteenth 210
Entry, the Nineteenth 226
Entry, the Twentieth 228
Entry, the Twenty-First 229
Entry, the Twenty-Second 230
Entry, the Twenty-Third 238

Acknowledgments 251
About the Authors 254

List of Characters

Aglaranna: Elf Queen in Elvandar, later wife of Lord Tomas.

Alma-Lodaka: Valhur, Dragon Lord, Emerald Lady of Serpents. Creator of the Pantathians and the Saaur.

Amos: Trask, former pirate, "Captain Trenchard," later companion of Prince Arutha, later companion of Prince Nicholas and Calis in Novindus.

Anita: Princess of the Kingdom, daughter of Prince Erland of Krondor, later wife of Prince Arutha.

Arutha conDoin: Prince of the Kingdom, second son of Lord Borric of Crydee and brother to King Lyam, later Prince of Krondor.

Arutha Jamison: son of James (I) and Gamina, Lord Vencar, Baron of the King's Court, father of James (II) and Dashel Jamison.

Ashen-Shugar: Valheru (Dragon Lord, Ancient One), Ruler of the Eagles Reaches.

Baru: "Serpentslayer," Hadati hillman, companion to Prince Arutha in Armengar.

Borric conDoin (I): Duke of Crydee, father to Lyam (I), Arutha, and Carline.

Borric conDoin (II): Prince of the Kingdom, son of Arutha, brother to Erland (II), later King of the Isles.

Brendan conDoin: son of Henry (II), brother to Henry (III) and Martin (II).

Caleb: youngest son of Miranda and Pug, brother to Magnus, half-brother to William and Gamina. Husband of Marie, foster father to Tad, Zane, and Jommy.

Calin: elf heir to the throne of Elvandar, half-brother to Calis, son of Queen Aglaranna and King Aidan.

Calis: son of Aglaranna and Tomas, half-brother to Calin, later "The Eagle of Krondor," special agent of the Prince of Krondor, Duke of the Court.

Carline: Princess of Crydee, daughter of Lord Borric, sister of Lyam and Arutha, later wife to Laurie.

Dashel Jamison: "Dash," younger son of Arutha (II), grandson of James (I), brother to James (II), later Duke of Rillanon and grandfather to James.

Dolgan: Dwarf Chieftain at Village Caldara, later King of the Dwarves in the West, holder of the Hammer of Tholin.

Draken-Korin: Valheru (Dragon Lord, Ancient One), Lord of the Tigers.

Edward: cousin to Ryan and Gregory, later Prince of Krondor.

Emerald Queen: see entry for "Jorna."

Eiek: von Darkmoor, apprentice blacksmith, boyhood friend of Rupert, later member of Calis's "Desperate Men," later Sergeant, then Captain of the Crimson Eagles, later Knight-Marshal of the Kingdom.

Erland (I): Prince of Krondor, uncle to King Rodrick, father of Princess Anita, cousin to Lord Borric and family.

Erland (II): Royal Prince, son of Arutha and Anita, younger twin to Borric (II), later Prince of Rillanon.

Gamina: adopted daughter of Pug and sister of William, wife of James (I), mother of Arutha (II).

Gardan: Sergeant at Crydee, later Knight-Marshal at Krondor.

Gregory: son of Patrick, younger brother to Ryan, later king after his brother, cousin to Richard and Edward.

Guy: du Bas-Tyra, Duke of Bas-Tyra, later Duke of Rillanon.

Henry (I): "Harry," son of the Earl of Ludlum, companion of Prince Nicholas, later Governor of the Sunset Isles.

Henry (II): "Harry," Duke of Crydee, father to Henry (III), Martin (II), and Brendan.

Henry (III): "Hal," Duke of Crydee, later King Henry V of the Isles, husband of Stephané of Roldem.

James: Jimmy the Hand, later Duke of Rillanon, then Krondor, father to Arutha (II), grandfather to James (II) and Dasher.

James (II): Jamison, son of Arutha (II), brother to Dasher, grandson of James (I), later Duke of Rillanon, grandfather to James (III).

James (III): Jamison, "Jim Dasher," spy for the crown, grandson of James (II).

Jorna: "Lady Clovis," later Emerald Queen, wife of Macros and mother of Miranda, later wife of Nakor.

Kaspar: Duke of Olasko, later exiled in Novindus, later servant of the Conclave of Shadows and defender of Kelewan against the Dasati.

Katala: Thuril slave girl in Kelewan, later wife to Pug and mother to William.

Kulgan: magician at Crydee Keep, Pug's first teacher, companion to Meecham.

Laurie: troubadour, later slave with Pug on Kelewan, later Duke of Salador and husband of Princess Carline.

Leso: Varen, also known as Sidi, mad magician, servant of the God of Evil, pawn of the Dread, confidant of Kaspar of Olasko.

Locklear: squire of Prince Arutha's court, later baronet and court baron, friend of James (I).

Lyam (I): son of Lord Borric, brother to Prince Arutha, later King of the Kingdom of the Isles.

Lyam (II): son of Prince Arutha, brother to Prince Borric (II), Princess Elaina, and Prince Nicholas.

Macros: the Black Sorcerer, father of Miranda, grandfather of Magnus and Caleb.

Magnus: son of Pug and Miranda, grandson of Macros the Black.

Marcus: son of Martin (I), Duke of Crydee, cousin to Prince Patrick.

Martin (I): illegitimate son of Borric (I), half-brother to Lyam (I) and Arutha (I).

Martin (II): son of Henry (II), brother of Henry (III) and Brendan.

Meecham: "Franklin," freeborn land owner, hunter, companion to Kulgan.

Miranda: magician, daughter of Macros and Jorma, later second wife of Pug, mother of Magnus and Caleb.

Murad: Moredhel chieftain of Clan Raven, servant of the false Murmandamus.

Murmandamus: false prophet of the Moredhel, disguised Pantathian Serpent Priest.

Nakor: Isalani gambler from Kesh, companion to Princes Borric and Erland, later to Nicholas, then Pug, Magnus, and Macros. Second husband of Jorma. Sometimes known as "the Blue Rider."

Nicholas: youngest son of Arutha (I), brother to Borric (I), Erland (I), and Elena, later Admiral of the King's Bitter Sea Fleet.

Oracle of Aal: ancient seer of the oldest known race in the universe. Saved from a dying planet by Pug, her mind inhabits

the body of the ancient dragon Ryath; also known as the jeweled dragon, the Oracle at Sethanon, or simple the Oracle.

Owen: Greylock, Swordmaster of Darkmoor, later captain in the Prince of Krondor's army.

Patrick: son of Erland (II), nephew to Borric (II), Nicholas, and Elena, father to Ryan and Gregory.

Pug: orphan boy from Crydee, also Milamber of the Assembly of Magicians on Kelewan, also Pug of Stardock, founder of the Conclave of Shadows, also the Black Sorcerer after Macros the Black.

Richard: cousin to King Patrick, caretaker of Prince of Krondor before Edward.

Robert: "Bobby" de Loungville, sergeant in Calis's Crimson Eagles.

Roald: mercenary soldier, boyhood companion of Laurie, later companion of Arutha at Armengar.

Rodric IV: King of the Isles, cousin to Lord Borric and Princes Lyam and Arutha, nephew of Prince Erland.

Rupert "Roo" Avery: boyhood companion of Eric von Darkmoor, later member of Calis's "Desperate Men," later young merchant of Krondor.

Ryan: son of Patrick, brother to Gregory, later King of the Isles.

Stephané: Princess of Roldem, daughter of King Carole, later wife of Henry (III) and Queen of the Kingdom of the Isles.

Talon of the Silver Hawk: also known as Talwin Hawkins, trial boy from the mountains, father of Tyron Hawkins.

Tomas: kitchen boy from Crydee, later inheritor of the Dragon Lord's armor from Ashen-Shugar, later Warleader of Elvandar and husband of Aglaranna, father of Calis.

Tyron Hawkins: son of Talwin Hawkins, companion of Duke Henry (III), secret apprentice for James (III).

Valko: Dasati Deathknight, later ruler of the entire Dasati Empire.

William: son of Pug, brother of Gamina, later Knight-Lieutenant in Krondor, later Knight-Marshal of Krondor.

To you, the reader, an introduction...

YOU ARE COUNTED AMONG A SELECT FEW, *those entrusted with the innermost workings of the Conclave of Shadows. If you are reading this, be you student at Stardock or on Sorcerer's Isle, noble of the Kingdom, or close ally of the Conclave, know that only a handful of others have been granted access to the material compiled between these covers.*

Here you hold a copy of what began as my father's journal, as much of it as he could manage to compile during his lifetime. I chanced upon it while attending to the matter of my father's possessions after I inherited his mantle as leader of our community, here on Sorcerer's Isle.

I will confess that upon finding it, I only intended to skim through it, and then consign it to one portion of his library or another, but as I began to read, I realized how little I knew about my father's early life and those experiences that shaped him. So it was with interest I read of his youth and those early adventures that formed a perspective set hard and fast by the time I was old enough to begin my education.

I found those bits of narrative and commentary on his discoveries a fascinating tale, one that spoke not only of the great deeds that are chronicled in other volumes, but also of the small events that contributed to the making of a man. By most common standards, my father was elderly when he wed my mother, though to outward appearances he was a robust man of middle years, of short stature and slightly greying black hair, but otherwise apparently little marked by time. Yet the truth is he was a century of age and more, for it is our blessing, or curse as you may see it, that provides those of us gifted with magical abilities with, if not eternal youth, then at least a very slowly advancing old age. For me, finding these glimpses into my father's past was welcomed; I learned that he had once been a boy, a callow youth, and a young man forged in the crucible of adversity; and, in gaining this glimpse into the boy, I better understood the man.

I decided to do my part in organizing this volume a bit more than my father had. He was a man of considerable gifts and remarkable talents, but organizing small things was never his knack; he always had others who saw to the details, so in this, I am the last of those to do so.

As I attempted this small endeavor, I realized I had two advantages of perspective over him. First, my father and I have discussed many of the topics he has written about, and thus, I was presented with what he wrote here and what he told me years, sometimes many years, later; this was instructive on how the memory often shifts and modifies events in one's mind. Second, over the years I have spoken to others who have witnessed various events chronicled here and elsewhere, and the difference in that perspective is also informative.

I added commentary where I might, as well as some notes and information given to me by others, either from direct recollection or reliable hearsay. When diverse sources were balanced, I believe a fairly accurate representation of true events was achieved; in other cases, while accuracy may be less, the value of the tale was such that I included it. Occasionally the choices were motivated by my affections for my father, rather than judging the event of historical weight.

My father was by nature a modest man, one who saw himself thrust by circumstances into a role he did not wish, or choose, but I believe with that self-effacement he did himself a disservice, for while his critical role in history may have been foreordained by forces larger than himself, his choices within that role were uniformly heroic and self-sacrificing. I may be alone, or one of a very few, who truly understands the scope of my father's personal sacrifices and the horrible burdens he chose to shoulder alone, to preserve this world and protect those he loved. He never once asked to be thanked or even cared if others knew what he suffered.

His is a story worthy of being told. So, with my occasional annotation, I present you what I choose to call the Chronicles of Pug.

—Magnus of Sorcerer's Isle

Entry, the First

IN THE SECOND YEAR OF THE REIGN of King Lyam the First, I, Pug of Crydee, magician to the royal court and cousin to the King by adoption, do take quill in hand and set forth this account, that all may benefit from the knowledge I have gained. My purpose is to ensure that what has been learned is not forgotten, for life has taught me that death is her constant companion. Much has been bestowed on me and it must endure beyond me, so this is my cause.

To understand what I have learned, one must abide some tales of my life. I will deal with the discoveries of my travels, but first I need to share who I am. I do not speak of myself for purposes of aggrandizement or out of vanity, but rather to explain how I learned, and to present other worthies to the reader, people far more deserving of praise and thanks than I, so their achievements may be widely known and their contributions appreciated.

I further avow that much of those accomplishments credited to me are rather the fruits of labors, struggles, and sacrifice by others, many giving the ultimate sacrifice in the conflicts we endured. Where possible, their names will be noted.

The preponderance of the material I present here within came from the library of Macros, called the Black Sorcerer by many, and a figure of some legend in the region of the Bitter Sea and its surroundings. He was an agent of the gods, as much as any man, and as such a good and faithful servant, though at a price upon which I can only speculate. He lost much in that service and I pray he found respite and reward in whatever fate awaited him at the end of the Riftwar.

He bequeathed to me a marvelous legacy, Sorcerer's Isle, site of the legendary Black Castle and the hidden Villa Beata, or "beautiful home." Within that villa resided his library, full of maps, journals, accountings, histories, and other notes and scraps as would come to him. Of organization there was none, so realizing the vast wealth of knowledge here, I have undertaken to bring something of order to these many items.

As anyone who knows me well will attest, I am a man of some skills in the magician's arts, but I lack the true discipline needed as an Archivist. I may, at some later day, entreat the aid of another to bring order out of this chaos and find better arrangement to these many bits of knowledge than I have achieved, but here at the start, I will seek to do my best.

I hope that whoever you may be who reads this, you will appreciate that all here within was compiled by a man of small gifts in such a task and forgive whatever flaws you may find. I am, your humble servant,

—*Pug of Stardock,*
known to some as Milamber of the Assembly

The above was written by my father as he began to organize the materials in this volume. This was before my birth, even before he met my mother, by many years. Much of what he observed as he organized lacks the perspective of later years, so if any notes by my father are inconsistent with later discoveries or findings, that is the reason. I will undertake to allow my father's comments to stand, unless my additional comments correct errors or otherwise add perspective.

—*Magnus*

Section I

THE RIFTWAR

SINCE MY FATHER'S BIRTH there have been five dimensional wars, yet when he began this chronicle, he had experienced only the first and thought it unique. What follows is my brief account of the history of those five wars; hopefully my words will provide further insight into the times and my father's life.

The Riftwar

The Riftwar was an incursion into our world by the nation known as the Empire of Tsuranuanni, during the reign of King Rodric IV. The Tsurani reached Midkemia via a "rift," also known as a dimensional portal or gateway, allowing instantaneous travel over vast distances, between worlds, and possibly through time, though this last is speculation on my part. At first it was judged they had come seeking to conquer for metal, as their own world was metal poor. In time the truth was discovered: This was one ploy in a complex game of politics back on their world, with thousands of lives being spent simply to advance one side's cause.

Father was taken early in the war and made a slave in the Tsurani world, Kelewan. It was there his true ability manifested and he was taken to study by the magicians of that world, as the ability to practice what they call the Greater Path Magic conferred a status irrespective of previous rank, hence a slave from another world was elevated to a position among the most powerful and important members of that society.

My father's role in that war has been chronicled elsewhere, but in summation it can be said he was instrumental in ending that conflict and eventually bringing peace to both worlds. But it was a peace that was all too fleeting, for forces elsewhere were already in motion, preparing for the next assault on "Midkemia"....

The Serpent War

There resided on Midkemia a race of serpent beings, the Pantathians. They proved to be instrumental pawns in a conflict that existed ages before my father's birth and will no doubt linger long after I have passed on to whatever awaits after this life.

During the early days of the reign of King Borric, these Serpent Priests again arose to plague the Kingdom with another plot, and began another bid to take Sethanon and the Lifestone.

The Pantathians had discovered a rift to the world of Shila, home to a race of lizardlike beings, the Saaur. The Pantathians betrayed the Saaur, unleashing a demon host on their world, eventually forcing the Saaur to flee to Midkemia. Their participation on behalf of a demon disguised as a human, the Emerald Queen, led to the bloodiest of conflicts in recent history, and the destruction of much of the Principality of Krondor. When the deception was unmasked, the Saaur quit the struggle, and the invading host was stopped at the legendary Battle of Nightmare Ridge.

The Dark War

Again an attempt was made to invade Midkemia on behalf of the dark forces seeking to overthrow the calm order of things and install a terror unimaginable over the world. A rift through dimensions this time allowed a race of beings known as the Dasati to invade our universe, on the Tsurani home world Kelewan. They were powerful warriors and deathly priests, and each alone was a match for a half-dozen human warriors or magicians. Only the combined efforts of armies from two worlds held them at bay until my father, Nakor, and I could reach the source of this terror and destroy the passage between worlds, but at a terrible price. The obliteration of the world of Kelewan and most of its inhabitants saved our entire dimension from utter destruction.

THIS MAP OF TRIAGIA hangs on the wall in my study, where Macros the Black originally placed it. It faithfully depicts the continent.

These events forever changed my father, for within him dwelled regret beyond imagining at the loss of life and the destruction of ancient cultures. While many Tsurani, Thuril, and other inhabitants of that world were relocated to a safe, new world, four out of five souls perished in that final battle with the Dasati.

THIS IS A MAP OF THE KINGDOM OF THE ISLES, an exact copy of one in the Royal Library at Rillanon. It was a generous gift from King Lyam after I had admired it within his hearing.

The Demon War

The Demon War was a conflict between rival demon kings that unfortunately spilled over into Midkemia, forcing my father and our brother magicians in the Conclave of Shadows to take a hand. It was here two things of note occurred: my mother and brother were lost in the struggle, further driving my father into a place few can imagine, his heart forever in darkness, and our final understanding that every event from before the first Riftwar was but a single conflict in an ongoing struggle between forces nearly unimaginable to mortals. The utter destruction of a large portion of the demons' realm led to events that culminated in the final struggle.

The Chaos Wars

The Chaos Wars were thought to have been the original struggle between the Blind Gods of the Beginning and those beings who occupied Midkemia, elven-kind and dragons, and the new gods and all who came after: humans, dwarves, and goblins.

At the end of the struggle, we realized that all these conflicts were but part of a seemingly eternal clash between incredible forces with the fate of all reality hanging in the balance. Even then, nothing could have prepared us for what would come after.

My mother returned, at least in a sense, as her memories had been grafted onto another being, and for my father and me it was a difficult time, for here before us stood the exact likeness of one dear to us both, yet one who was really not her. In time we adjusted, and after even more time, we accepted this being, a demon with my mother's face and mind.

For reasons that will become apparent, the last narration of this chronicle of my father will be mine alone, for my observations are a postscript to his life. Yet much of what my father was lives on in me, or at least that is my hope, for he was and remains one of the most remarkable individuals to have ever lived. I say this as a son filled with pride, but also as a student of history, and feel safe in asserting that every living creature on Midkemia owes their continued existence to my father's sacrifice.

The maps that follow this section are old, current at the time of the events referred to in the opening section of his chronicle. My father obtained the first map from Macros's library, and the second was a gift from King Lyam; both are accurate in regard to the continent of Triagia and the Kingdom of the Isles as they existed in my father's youth.

There are three continents on Midkemia, the largest of which is Triagia, a massive body of land extending far into both hemispheres. Many nations and people call Triagia home, but the two most powerful nations by far are the Kingdom of the Isles to the north, and the Empire of Great Kesh to the south. The island Kingdom of Roldem is notable for its influence in the arts as well as its sizable navy. Its presence has often kept the two larger nations from needless conflict over the years.

—**Magnus of Sorcerer's Isle**

Entry, the Second

THE FAR COAST OF THE KINGDOM OF THE ISLES is home to the Duchy of Crydee, the most distant province of the Kingdom. Without magic, travel to Crydee from Rillanon is arduous and lengthy.

Crydee is home to Duke Martin, brother to the King, and his family. It was his father, Borric, a most worthy and just man, who was Duke at the time my story begins.

After some travels, I feel safe in observing that in many ways the Far Coast is a different culture from the rest of the Kingdom of the Isles. Three generations of relative isolation have resulted in a rougher character, less refined, more rustic, and in some ways a character more virtuous than to the east.

Not that men and women of virtue don't exist to the east, but rather the overriding concerns of other Kingdom nobles—advancement, politics, power, and gain—are absent along the Far Coast. The inhabitants of the Far Coast are more occupied with the daily exigencies of life, and little more.

The Duchy of Crydee is as simple as any in the Kingdom, consisting of three boroughs: Tulan, a barony; Carse, an earldom; and the duchy home itself. If three noble families could be considered close, it would be here, for lacking the constant political bickering common to the East, and relying far more upon one another than any help coming from the rest of the Kingdom, these noble families are more like kin than vassals and lord.

I presume to weigh matters unknown to me at the time, but reassessed by knowledge gained after the fact, but it was only the royal blood of the Duke's family that conferred any status for Crydee in the Congress of Lords and the royal courts of Rillanon and

Krondor. I suspect absent that, Crydee would have been left to linger neglected. As it was, it was greatly left to its own devices until the coming of the Tsurani.

Crydee was both abundant and harsh. It consisted of woodlands and deep forests, mines and meadows, farmland and mountains, rivers and game in profusion. It was a rich land, more than capable of supporting the population there, but it was hardly an idyllic place, for we had neighbors, not all of whom were affable.

To the north dwelled the elves, servants of the Queen, Aglaranna, and to the southeast lived the dwarves, under the command of their chieftain, Dolgan. We lived in peace with these people, rarely passing on their lands, they rarely visiting ours. We occasionally traded with the dwarves, their fine ale bringing a premium, and our seafood being a delicacy to them. The elves were content to keep their own counsel but occasionally welcomed our hunters, most notably the current Duke, Martin, when he was a boy. Of all men in the Kingdom, he perhaps understands the elves most of all.

Not all our neighbors were so affable. We also were cursed with the marauders of the Brotherhood of the Dark Path, as the dark elves were known to us. I later learned they were known as the Moredhel in their own tongue. They were at times served by goblins, foul creatures with wolf-like visages, who raided and killed for sport and sacrifice to dark gods. Trolls and other creatures also troubled us from time to time, so despite Crydee's bounty, we were forced to be ever vigilant. Add to that the constant threat of predation by lions, bears, wolves, wild dogs, and the occasional wyvern, and it was a foolish traveler to move through the duchy without stout weapon or large company, and who trod anywhere but the King's Road between Tulan, Carse, and Crydee Keep. Most travel was achieved by ship as all three towns boasted welcoming harbors.

Within the boundaries of the towns and villages, and upon the farmsteads, herd, and lumber camps, relative safety was assured, and within the woodlands near those populations as well. But the Green Heart was always dangerous, and its threats became manifest

THIS MAP OF THE FAR COAST was found in Macros's library on Sorcerer's Isle. It is similar to one kept in Duke Borric's study, though both possess minor inaccuracies. I suspect they were due to the mapmaker's working from other people's descriptions rather than firsthand knowledge of a given area. Still, on the whole, this map is reliable enough that a traveler to the Far Coast would have little reason to fear getting lost. Detail is lacking in some places, however; should it not be obvious, areas that appear empty and fringed by trees, such as the Green Heart and north of Elvandar, are in truth heavy forest. A copy of another map from Lord Borric's study, showing the significant landmarks, trails, roads, and other features of interest of Crydee and the surrounding area, from just before the Tsurani invasion.

to me personally, as did the perilous foothills of the Grey Tower Mountains to the east of the duchy. A single road from Crydee over the mountains to Yabon and another to the south and over to the Free Cities were the only relatively safe passage, and even then attacks by bandits, as well as the dark elves and others were a constant threat.

As stated, I was a foundling, left on the doorstep of the Abbey of Dala in the foothills of the Grey Tower Mountains. A mendicant order, the monks could not care for me, so they took me to a most remarkable man, Lord Borric conDoin.

Lord Borric possessed many fine qualities, but first among those was a sense of justice and compassion. Without pedigree I could have been pronounced a bond servant, requiring twenty years of service to whoever held my bond before calling my life my own. He judged it far more just to let a bondsman's child be free than consign a freeborn child to a bond. I was given to Magya, the cook's wife, to rear, as she just had given birth to a boy, and raising two side by side seemed as natural to her as if she had borne twins. So I was raised as their son, alongside my foster brother, Tomas, due to the generosity of that most remarkable man, Lord Borric conDoin.

As a boy of the keep, I had duties from as early as I can remember. At first my world was the kitchen, for Megar, the cook, and Magya occupied a small room behind the kitchen proper. Tomas and I played at their feet until we were old enough to be given minor chores. I can't remember a time I didn't have duties in the kitchen, and my earliest memory is of sneezing from flour dust, followed by one of falling a great deal as I tried to herd chickens back into their roost. I had opened the coop door and set them free by accident.

Washing, peeling, and chopping vegetables, plucking birds, stirring simmering stock, and cleaning every implement and surface in the kitchen became second nature to me. As I write this, it's been more than two decades since I lived in that kitchen, but I wager I could cook Megar's seafood chowder from memory this very day.

Given the close quarters of the small room the cook and his wife occupied, at an early age Tomas and I took to sleeping wherever we found ourselves late at night, most often on the kitchen floor near the baking ovens in the winter, or outside during the summer heat. I look back from many years later wondering how I slept so soundly on the stone floor or hard-packed dirt, yet I did.

As I grew, first the keep, then the town of Crydee became familiar, my home ground enlarging as I roamed more at will. Getting into town was a treat for keep boys, as we had very little time to ourselves. We of the keep were self-sufficient in many ways, for the Duke's taxes often came in the form of livestock, grain, lumber, or stone, but in the town were items that appeared exotic by a young boy's standards. Cloth from distant lands, which shone in the afternoon sun, exotic spices I rarely encountered in the Duke's kitchen, and other seemingly novel items, and of course the town girls.

Tomas always caught their eyes. He was tallest among the boys our age and had a confident, easy grace to his manner. He was by any measure a handsome fellow and was easily the best among us at running, climbing, brawling, or any other skill I could name. He was confident he would become a soldier, and to the girls of Crydee that made him a bit dashing, I think.

I, on the other hand, was small and quiet, and any attention I received was only Tomas's reflected glory. His presence kept me from being bullied a great deal more than I should have endured, and for that I was grateful.

As every boy in Crydee was required, upon my eighth Midsummer's Day, I began to apprentice or train with various crafts throughout the duchy. This practice had begun with Lord Borric's grandfather, the first Duke of Crydee, who had quickly come to understand that his newly established duchy lacked enough skilled laborers at harvest, or when it was time to bring the herds down from the alpine meadows before winter, or to help repair storm damage. He decreed that every boy would spend at least a few weeks helping at all the important crafts.

So for five years I would spend one week out of four helping at carpentry, mending fishing nets, stoking the forge, or doing any other task that someday might be my own. Through this process two goals were achieved: masters learned the strengths of boys who would soon stand for Choosing, when all boys age 14 stand to be taken as apprentices by the masters of various crafts—some had no sons of their own, and some boys had elder brothers apprenticing and found no place to work at their father's side—and we boys were acquainted with the requirements of the various crafts to better enable us to understand where our futures might be best served.

Another consequence of this practice was we learned to appreciate just how difficult various trades and crafts were; what might seem to be trivial or easy in accomplishment was in truth significant or difficult. It raised our appreciation for the skills and abilities of other men and also gave us a better understanding of the roles played by women in our duchy, beyond the more obvious of wife and mother.

The last benefit of this practice was travel, or perhaps exploration would be a better term, for one of the ironies of my life is that while I

I'LL ADMIT TO BEING AMUSED TO DISCOVER that the mapmaker called the road north from Crydee the Great Coast Road, as no one in Crydee called it that. It was an extension of the King's Road that was never built. Lord Borric's father attempted to clear away a fair bit of it to aid deep forest lumbering, but given that everything east of the coast hills was patrolled rarely, there was little use of it, and it fell into disrepair, effectively vanishing into the hills to the east of the Yarnor Mine and the village of Buusbers.

Smuggler's Hole and Faraway are also worthy of a brief mention. Smuggler's Hole was named after the Duke's father raided a nest of smugglers who had been utilizing the cove there to move weapons from Kesh up over the Great Northern Mountains to renegade humans and the Brotherhood of the Dark Path.

Cliffs

Grass/Meadow

Trail

Primary Road

Secondary Road

Farmland

1 MILE GRID

Map of Crydee and Surroundings

- To Road's End
- The Great Coast Road
- Faraway
- Smuggler's Hole
- Sailor's Grief
- Jarnor Mine
- Buushers
- Crydee
- Bryan's Hold
- Longpoint Lighthouse
- Reed's Ferry
- Ferry Crossing
- Crydee River
- Longbeside
- Portertown
- Little Quiet
- Torin's Edge

have ventured to another world, I would never have visited Carse and Tulan save for my stint apprenticing as a wagoner on one occasion and a sailor on another. That is how I first came to travel within Crydee.

The Duchy of Crydee, as granted by the Crown to Lord Borric's grandfather, extends far to the north of where it ends in reality. A colony village, by name Brisa, was established by the second Duke, but it failed in less than two years. While the Kingdom may claim lands as far north as where the Great Northern Mountains meet the sea, in actuality the King's law ceases at Road's End. A small garrison town, it is home to a handful of fishermen, farmers, and herdsmen who tend the needs of the tiny garrison, situated halfway between the river known as Rushing Deep, and the Crydee River, known to those of us who live in the duchy as River Boundary, for it is the river that marks the southern limit of the forests that surround Elvandar.

Carse, not Crydee, is the commerce center of the Far Coast. Carse has the best of the three harbors, and the only one suitable for more than two or three deepwater ships. Crydee has a long pier running the north side of the harbor, but it can accommodate one large or two small ships at most. Tulan is situated on a series of small islands linked by bridges and hand-dug landings for small boats, so all ships must anchor offshore and goods are ferried by barge or shallow draft boat.

My first journey, to Carse, began in the summer just after my ninth year. I was full of excitement as this was to be my first journey outside of Crydee. The days were hot and travel was tedious and the excitement quickly diminished. Still, for a boy of nine the slightest change in scenery held a hint of the exotic.

The Far Coast is unforgiving save for a few stretches near the three main ports. The most notable bluff is a headland west of Crydee known as Sailor's Grief. The shape of the coast there is deceptive with a rapidly rising shelf just below the surface. More than a few unsuspecting ship's captains have sailed nearby in a following wind in what seems deep

water, only to be pushed onto the rocks by the ocean surge meeting the tide race from the Crydee River.

The rest of the coastline between Crydee and Carse is hardly more forgiving, and where there is a small stretch fit for landing, there is only one village on the shore, the fishing community of Windswept. Other villages like Road Town and Seaside are either on bluffs overlooking the sea or above inaccessible beaches or rocky coasts where landing boats is impossible. Where the beach can be reached from the King's Road, there is usually a steep, narrow path, little more than an animal trail.

Such natural obstacles have contributed to the rarity of pirate raiding that troubles the western coasts of Kesh and the ports of the Free Cities in the Bitter Sea. The only safe place to come ashore in numbers is within the harbors of Carse and Crydee, and they are well defended. Tulan also offers other problems for attackers.

My first reaction on seeing Carse was that it was a much larger community than Crydee. In my boyish world, Crydee would have to be the superior town, being the home to the Duke and all. As I learned, the original Duke had picked that location as the first defensible position he could seize, allowing reinforcement from the sea, after crossing the Grey Towers in the conquest of what was then Keshian Bosania.

After securing that position, the original keep tower was built—now the northwest corner of the Duke's castle—and a year later what became known as the Southern Campaign began. Carse was the largest of the three Keshian enclaves to fall to Duke Borric's grandfather and was a prosperous trading port compared to Tulan. The major export to the Empire was hard oak, a species that didn't exist in the Empire of Great Kesh and one superior for shipbuilding.

To my unschooled eye, Carse was a beehive, people swarming everywhere, an impression I carried with me for years until visiting larger cities. There were a half-dozen good-sized ships in the harbor, whereas Crydee rarely had more than one at a time in port.

I learned later these were still small ships by Kingdom standards, coasters that rarely braved deep waters.

I had yet to undertake that portion of my training concerning boats and their handling, so what I recall is sketchy but I do remember a busy port, with many barges and boats carrying cargo to and from the city.

Carse was my first venture away from home, along with a wainwright named Francis, his apprentice, and three other boys. We were delivering two newly made wagons to a farmer who was meeting us in Carse. I and another boy took turns driving one small wagon, while the other pair of boys drove the second. The apprentice, a quiet lad named Teddy, moved from wagon to wagon, so we all had his tutelage, as well as some time on the big wagon with Master Francis.

I was looking forward to spending the night in an inn with hot food and stories from travelers of far-flung lands, but we housed in the stable with Teddy while Master Francis partook of the inn's comforts and departed the next morning. I was disappointed more over not being permitted to explore Carse than spending a night on damp straw.

Still, it had been my first taste of adventure and for a lad of nine I had not disgraced myself in driving a team. I was well satisfied, though I knew before the journey was half over that I had no desire to be either a teamster or a wainwright.

My second journey was by boat, down the coast to Tulan, to carry messages to the Baron of Tulan from my lord Borric. It was here I discovered I had neither any aptitude for sailing nor love of the sea. The water was choppy and while I didn't get seasick, neither was I fully at ease. The work was hard; I was the youngest lad aboard and the smallest, but thankfully I endured no task alone, so things were done in good order. My hands were already calloused but the ropes—stays and sheets as the sailors call them—burned my hands, and by the time we reached Tulan my palms were raw. I was told salt water would toughen them.

Tulan was fascinating once we dropped anchor, for it was originally a fortress on a rocky isle in the mouth of a large river. To reach Tulan, you sail along the coast, then turn toward a headlands and beat against the tide and wind into a small bay, not really more than a deep inlet, to a series of small islands that cluster there.

The original fortification was designed as a defensive position against any incursions from Kesh attempting to retake Bosania from the Kingdom. Initially there had been a hastily erected wood-fenced compound behind a good-sized dock and three ships anchored a short distance away. These composed the entirety of the Duke's fleet and were the only Kingdom ships beyond the Straits of Darkness.

By my first visit to Tulan, the old wooden fortification had been supplanted by a full-sized stone keep, including stables and yard, occupying the entirety of the island, save for the docks. As a result, the community of Tulan had sprung up on the nearby islands, many of them connected by bridges, most by dock and boat, and a unique town had evolved.

When weather permitted, the passages between islands—naturally occurring parts of the estuary supplemented by a handful of man-made canals—were thronged with boats and barges moving goods and people from island to island. I found the entire tableau fascinating. It was late spring so the weather was warm and the breezes gentle, and everything about this town felt exotic.

We spent three days in Tulan before departing back to Crydee, and rather than a stable as I endured two years before, we were allowed to sleep aboard the boat. We had meals fetched to us by servants of the Baron, and I could only imagine what life in this watery town would be like.

Perhaps someday I will return to Tulan should time permit, just to take a look around. The sailing home was uneventful but tedious as we had to sail away from the coast against the wind to avoid the rocks. That meant long tacks out to sea, then short runs back toward

the coast. It took us six days to return compared to three getting to Tulan, but at least by then my hands had toughened enough so the ropes no longer hurt.

My stint learning the hunter's trade took me through the woodlands surrounding Crydee. Martin Longbow, Duke Borric's son and now Duke after his father, was unrecognized then and served as the Duke's Huntmaster. He was a mysterious figure to we boys of the keep, coming and going like a shadow. His skills at hunting were matched only by those of the Rangers of Natal from the Free Cities, and exceeded by the elves, though even those elves with whom I spoke regarded Martin highly.

The woodlands within two days' hike around Crydee were rich with mystery and magic for boys away from family, stalking game and wondering if we possessed the skills and temperament for the calling. The Duke's hunters were tasked with more than simply shooting deer and bringing meat back; they sought out poachers who were hunting the Duke's land without permission, as well as kept an eye out for any signs of incursion from the Brotherhood of the Dark Path, bandits, trolls, or goblins. They also watched for signs of diseased elk, deer, or other creatures that might contaminate the duchy's cattle, sheep, or goats.

I was paired with a lad named Elkins, son to a cobbler, for Megar would not spare both Tomas and I from the kitchen at the same time. He always complained the lads sent there to serve and learn were more hindrance than help, and in part that was true. More than one stew had been oversalted or bread taken too soon from the oven by an overeager boy serving his first few days in the Duke's kitchen.

Elkins appeared to have no talent for hunting, but I fancied my skills better than average. I could hit what I was aiming for with a bow often enough, if the target was a tree that wasn't moving, but though it sounds immodest, I was deadly accurate with the sling, and I presumed that skill would somehow translate to improving with a bow should I be given the chance.

So I ranged within the relatively safe environs of the woods around the duchy. To the south was the Green Heart, a forest so dense no one could find a path to the southern pass over the Grey Tower Mountains without skilled trailbreakers and guides. Within the dark glades of that massive forest lived all manner of beings hostile to humans. A particularly aggressive group of clans of the Brotherhood of the Dark Path, mountain trolls in the foothills of the mountains to the east, also roamed the eastern side of the forest, and bands of goblins also called the Green Heart their home.

When the Choosing finally was upon me, I stood in the courtyard of the Keep, before the duke and his family, fearing, like all boys, that I might not be offered any apprenticeship. Then, against reasonable expectations, Kulgan, my Lord Borric's magic adviser, chose me as his apprentice. At that moment, I was relieved to have any calling, not understanding how magic would become the heart of my existence.

My father glosses over a significant event in his youth, one that gave him his first advancement in his station. It is what first marked him as an adept at what is now called Magic of the Greater Path.

He was tasked to accompany Princess Carline, Duke Borric's daughter, on a picnic as her guardian, and they were set upon by a pair of lowland trolls who would otherwise have killed both of them. The stress of that encounter caused my father to reach deep within and discover power previously unsuspected, and in an unprecedented act, he destroyed the trolls with a magic spell. It was a watershed moment in my father's life. It saved them both, and as a reward, my father was elevated to the rank of Squire and given a place in the Duke's household.

Pug Destroys the Trolls

Entry, the Third

IT IS WELL KNOWN BY MANY THAT IT WAS TOMAS AND I who discovered the wrecked Tsurani galley on the shores below Sailor's Grief, and encountered the dying Tsurani warrior. That began a series of events, undertaken by Lord Borric to ensure the safety of the Far Coast from what was perceived as a dire threat.

The Elf Queen and her court came to Crydee, an event unprecedented, and after that meeting, His Grace determined he must personally carry word to Prince Erland in Krondor, for should the invaders come in force, Crydee was ill prepared to counter an invasion.

Our journey began with the decision to travel through the Green Heart, striking for the southern pass through the Grey Towers, as the northern pass was already visited by snow and would be impassable by the time we reached it.

In the Green Heart we were attacked by the Brotherhood of the Dark Path, barely escaping with our lives after having lost some number of brave soldiers who defended their Duke, Prince Arutha, me, and Tomas. Kulgan, my master in magic, confounded their pursuit with a spell of enveloping fog, allowing us to find shelter in a cave in the foothills.

We were attacked in the cave by wandering goblins who bore signs of recent struggle, a harbinger of Tsurani incursion into the Grey Towers, though at that time we did not know this. We were found by Dolgan, leader of the dwarves in the Grey Tower Mountains. He agreed to guide us through ancient and abandoned mines leading from one side of the mountain range to the other, most notably an ancient mine known as the Mac Mordain Cadal, one spoken of in hushed tones by the dwarves and reputed to be home to ancient spirits and other horrors.

Reflecting on this journey years after, I recognize it was a unique and fascinating part of the journey, but at the time I was too overcome with worry to appreciate it. The tunnels of the mines were long and dark, emptying into large chambers where rich veins of ore had been removed by the dwarves centuries before. For all its dark and gloomy aspect, within the mines exists one of the most wondrous sights I have ever beheld.

In the heart of the mines is an ancient waterfall, one shifted underground by an earthquake ages before. It courses through rock and percolates down to where it again gathers as a torrent, and within a vast cavern as high as any tower at Crydee, it spills into a deep chasm. The unique thing of it is that the water has leached minerals along the way and when the light of lanterns shines on it, the falls alights in rainbow hues, glimmering and shimmering, with flecks of gold and silver throughout. More, when the lanterns we carried were shuttered, the water continues to glow with a spread of colors that in my youth seemed magical in nature.

Both Dolgan and Kulgan explained to me later how the minerals come to interact with light, but there are moments in life where the wonder of ignorance is a little more gratifying than the clarity of understanding; this was such a moment, perhaps the first such in my life.

I have witnessed great and majestic sights, unleashed power I once would have judged impossible, and have traveled as few men have, yet in my mind, those falls I once beheld were most wonderful. Perhaps it is as fundamental a thing as being a boy, seeing something for the first time. Few events in life match anything done for the first time.

The first time I made magic work, despite not knowing exactly how. The first time a girl kissed me. The first time I saw my son, William. All these things are etched in memory a certain way, and perhaps that explains why among the many wonders I have encountered, that waterfall deep within the dark depths of ancient mines under a mountain still endures so vividly in my memory.

Pug and Tomas Gaze at the Wreckage of an Alien Ship

The other, even more important event under the mountains was our encounter with a wraith.

There was a sense of foreboding traveling the old mine tunnels. The network of passages and galleries was thick with the dust of ages covering the floor. Looking down there were no signs of mortals passing before us in years beyond counting, yet from the first moment we reached the Mac Mordain Cadal, we felt as if we were not alone, as if some agency was watching us.

Later I leaned things about what occurred in the mines that threw a new light on those experiences. What I'm about to recount I'll tell in a manner that I hope reflects how I felt as those events unfolded, but one fact learned later I will share with you now: we were under the magic scrutiny of an ancient dragon, one of the most powerful members of that mighty race. That knowledge is important because events we saw as accidental at the time turned out to be related and causal, manipulated by powers that were planning years, even decades, ahead. We were also being observed by a far more malicious being lurking just beyond our view, one of the beings we know as a Child of the Void—the wights, specters, and wraiths, shadowy beings related in some fashion to the ancient and terrible creatures known as the Dread.

A wraith attacked our party, appearing out of the deep gloom of a large tunnel, and chaos ensued. A soldier lost his life before we knew the creature was upon us, and it was only through the stout leadership of Lord Borric we held our position and kept our lives. Kulgan used his magic to confound the creature and we made good our escape, but as we withdrew I realized Tomas had become separated from the rest of us and was cut off. He stood there in terror, and I felt the coldest chill of fear I had ever experienced in my young life seeing my foster brother standing there, helpless.

The wraith somehow sensed Tomas behind and turned his attentions to him. Tomas, the fastest runner in Crydee, left hesitation behind and took off down the large tunnel, fortunately carrying a torch, else surely he would have been lost.

It was not until years passed I learned the details of Tomas's escape, but as we found our way out of the mines on the other side of the mountains, I was bereft. Dolgan took it upon himself to return into the mines to find Tomas, and the Duke returned to his mission, carrying warning to the Prince of Krondor.

Years later Tomas and I both came to understand that this event, his running deep into the mines, was the presage of far greater dangers and threats to our world, but we were then boys, just beginning our respective journeys.

While events later gave me additional insights, there is still a great deal I do not fully understand regarding the part played by the dragon Rhuagh and why the wraith was stalking us; at that time it seemed a series of unconnected events. Now, however, I'm beginning to suspect that there is far more to this than I understand even now. While I have many duties that press upon me, and time is always in short supply, I intend to investigate certain questions about the dragons of Midkemia and the nature of the Children of the Void.

⚜ *This is the first notion made by my father to which I can point and say, here is where he began to suspect things that he would not understand for more than a century. As I reread the above commentary on his journey through the ancient mines, I'm struck by two factors: first, he had no inkling of how important his intuition about the nature of dragons and creatures of the void was; and second, had he, he might have been overwhelmed and driven to despair, for more than a century later, a far more mature, experienced, and battle-tested man, Pug of Crydee, was almost rendered helpless by those discoveries. I rarely hold to the notion that ignorance is bliss, but in this one instance perhaps it was, for the scale of what was coming was unimaginable to my father at that time.*

Entry, the Fourth

THE FREE CITIES are oddly related to Crydee historically. Both had once been part of the old Keshian colonial province of Bosania. One of the many revolts by the nations in the south of the Empire, what has come to be called the Keshian Confederacy, required the Empire to strip her northernmost garrisons and send those soldiers south, leaving the colonies of Bosania and Queg to fend for themselves.

Queg's answer was to adopt its own form of ruling caste, modeled after Kesh's "True-bloods," name a "King," and build a massive navy, becoming something of an outlaw nation, little better than a stronghold of pirates and raiders.

Within a few years of independence from Kesh, Queg attempted to assume rule over Bosania; the Far Coast was beyond its reach, for the nation lacked enough soldiers to garrison, and the voyages through the Straits of Darkness prevented continuous patrols, so Queg's leaders finally abandoned even the pretext of control.

The Free Cities endured Queg's control for a short while, and then revolted. Again Queg's ambition was blunted by a lack of ground forces, which is why the island nation has never managed to establish any presence on the mainland. After a few years of sporadic conflicts, the cities banded together in a confederation known as the Free Cities of Natal, signed a treaty with Queg, and a grudging peace ensued.

For decades the Free Cities prospered as Queg and Kesh both recognized a healthy trading partner was more desirable than an occupied colony constantly on the verge of revolt. The Free Cities used their resources to establish themselves as a source of rare minerals, fine timber, and other trade goods that Queg, the Empire, and, later, the Kingdom were willing to pay for.

Decades later, Bosania was invaded by the westward-expanding Kingdom, out of their Duchy of Yabon. I was told the conflict began over a trade dispute between Yabon and Natal, which escalated into the war of conquest. The Free Cities resisted successfully while the underpopulated Far Coast easily came under Kingdom rule. It was because of that war that relations between Crydee and the Free Cities were odd, at best; guarded, at worst. My lord Borric's fair treatment in trade seems to have alleviated some of that tension over the years prior to our journey.

While the Far Coast has been relatively isolated and left to its own devices by the Crown, the Free Cities have prospered and are constantly visited by foreign traders. The result was for the differences between the two, Crydee and the Free Cities, to become more distinct as time passed.

My first view of the Free Cities town of Bordon was tinged with exhaustion, fear for Tomas's safety, and worry about the possibility of a coming war with the Tsurani invaders. Still, with all that, I was instantly struck with how, at one and the same time, Bordon felt both familiar and foreign.

We had been intercepted en route from the mines by a company of Natalese Rangers, a quiet group who to me, in my youth, seemed somewhat odd. They recognized my lord the Duke from his tabard and were polite, especially since some of them knew Martin—there is a brotherhood of hunters, apparently—but they were also distant and insisted on coming with us to Bordon, where we hoped a ship awaited to carry us to Krondor.

So, dispirited and exhausted, we limped into Bordon, situated at the mouth of a small bay in the north region of the Free Cities. We were first taken to the office of the local prefect, who at first was cautious, then effusive in his welcome once he recognized my lord Borric's rank and business relations with a wealthy trader of that region, a merchant named Talbot Kilrane.

Master Kilrane, when he finally appeared and removed us from the prefect's office to his own home, was a welcoming and kind man. It was obvious to me he held Lord Borric in high regard, and whatever issues of politics that lingered between the Free Cities and the duchy had no impact on their relationship.

Time was precious and Master Kilrane made arrangements for us to depart as soon as possible, but I managed to find a little time to explore Bordon. When I was a boy, my farthest journey had been confined to the Far Coast, within Crydee, so Bordon was my first exposure to those of another nation. While so much was familiar, there was to the boy I once was an almost exotic quality to the place.

As mentioned, Crydee was not a major trading port despite being the Duke's home. So visitors from foreign lands were rare and noteworthy.

In the Free Cities, traders from every part of the Bitter Sea and beyond visited regularly, as the Free Cities often brokered trade between the Empire of Great Kesh and the Kingdom of the Isles even when hostilities had broken out between them. Ships from Queg never put in to Crydee, but three were at anchor in the harbor there, two small gaff-rigged luggers and a large trading galley with two banks of oars on each side.

Fashion was odd to me, as the Quegans sported tunics and trousers of wool, with cross-gartered sandals despite the weather turning cold. Those of rank favored heavy fur capes of wide variety, many with pins and fasteners made of silver, gold, or precious stone. Hats came in a variety of shapes and colors never seen before. It was my first exposure to fashion as a concern among men.

The travelers from Kesh were even more exotic to my boy's eye, dressed in all manner of clothing, from headgear to footwear, simple to ornate. One Durbin trader affected a head cover—I won't call it a hat—that looked as much like some strange and alien mantle of rank as a comfortable way to keep one's head warm.

A STYLIZED MAP OF THE BITTER SEA I found among Macros's collection.

Faces and voices were strange; I saw small men with flat cheeks and narrow eyes from the Isalani provinces of Kesh, as well as tall men with very dark skin. One of my lord Duke's best soldiers, Sergeant Gardan, is of Keshian blood, and his skin is as dark as any I've seen, but he speaks like everyone else at Crydee and his dress is as one would expect from a soldier. But these kinsmen of Gardan's ancestors wore colorful capes or kilts of leopard or lion skin, and they carried spears that were obviously more for decoration than warfare or hunting, as they were bejeweled and brightly painted.

The languages were strange to my ear as well, adding to the alien feel of this place. In the Kingdom we speak the ancient language of Rillanon, known as "the King's Tongue." There is another widely spoken language known as "the common tongue," or simply "Common," which is a traveler's and trader's language. It has many words from the King's Tongue, as well as Keshian, Roldemish, and the dialects of Queg in the Bitter Sea.

Having traveled since then, I realize that the root of this Common speech is mostly the Kingdom and Roldem, as they were the two most common seafaring nations on the Sea of Kingdoms. Trade with Great Kesh made it a natural speech along the very lengthy border of the Kingdom and Kesh, and there are towns, I've been told, where Common is the language of daily life, as opposed to Kingdom or Keshian.

To my youthful ear, this was all very exotic, and although most of my time was spent with my master, Kulgan, or with the Duke, his son, and the others of his party, I stole away enough time to drink in this strange and wonderful place.

I learned years after my first visit to the Bitter Sea that its name derived from the first Kingdom forces to reach its shores. In the hottest days of summer, the shore in many places becomes brackish and foul, a bitter aroma rising from it. It was always my impression that ocean air would smell like salt and cool winds, but this was how I was introduced to that being a myth.

The sea air in Bordon, upon the water, at Sorcerer's Isle, or in Krondor—each location has a unique tang to the air, varying even as the winds change. From Bordon, an icy chill could blow down from the mountains one day, while a hot wind could rise up out of the south on another. For the lad of fifteen summers who traveled for the first time, every sense was challenged and every assumption challenged.

The people I met were friendly despite historical conflicts between nations. The girls were captivating, partially because they were all new faces; one does get to know every girl of your own age in a small town like Crydee. Some looked just like the girls back home,

while others were foreign to me, being of dark skin and raven hair, or the almost golden hue from parts of the Empire. Fashions with the girls and women varied even more than among the men.

At supper that first night, the Duke shared his concerns with Master Kilrane who ordered his fastest ship, *The Storm Queen*, be made ready and placed at the Duke's disposal. It took a full day to ready that ship, the day in which I seized my opportunity to explore Bordon, and then we were off on the next leg of our journey.

I will confess now that as a boy I had little foreboding as to the coming Tsurani threat, so caught up was I in the adventure of travel. It helped me forget that my last vision of Tomas was him running into a dark tunnel in the mines deep under the mountain, a wraith in pursuit. Had I an inkling of what we would face in coming days, perhaps I would have been as worried about my own fate.

I will continue this narration of my first voyage across the Bitter Sea at another time, but to provide a sense of place, I'm including a map I consider both instructive and unique. It is a carefully copied "rutter," from the Prince's library at Krondor, the original being delicate from age. Used by captains without either magic aid or the ability to judge position by the stars and sun due to weather, this map shows elevations of most of the important landmarks, cities, and ports, so that by measuring the skyline of a city or shape of a landmark, the captain would know his position.

PAGES 50–51: ONE OF MY MOST CHERISHED POSSESSIONS—a "rutter" of the Bitter Sea, a gift from Amos Trask, showing how sailors unable to use the stars or magic to find their way along the coast identify their location by the outlines of cities and natural features.

BITTER SEA

Port Natal the finest of the Free Cities' harbor safe in all weathers. Harbor is closed with boom and chain. Non Free City ships must first dock at Fort Headman before proceeding into the harbor. The fort flies a large Natalese flag. Natal Bay is a confusion of channels that change after each spring flood. Get a local pilot.

Bordon a harbor of the Free Cities at the east side of the entrance to Natal Bay. For a Free City it is rich from the transshipment of barge cargo coming down the Great Mu. If you are watering here check the bottom of the casks for settled mud.

Natal Bay is a confusion of channels that change after each spring flood. Get a local Pilot.

Bay of Natal
Bordon
Port Natal
Herculus Point
Gladii Shoals
Queg
Island of Queg
Palenque

Margrave's Port is a harbor with a narrow entrance and rocky cliffs on either side but a deep clear channel. Rummored to be the home of pirates and wreckers. People are generally unfriendly. Crewmen should travel in pairs even during daylight.

Lan is a Free City Port with a tiny river harbor. There is a bar across the harbor entrance and most ships need to wait for high tide before entering. It sees some traffic in winter when cargos for the Far Coast are unloaded before being hauled over land to Tulan and points west.

Tulan
Margrave's Port
Lan

Tulan is the first Kingdom port on the Far Coast. It is a river port about 4 miles from the mouth of the Wyndermeer.

Straits of Darkness

Great Southern Rocks
Li Meth
Breaker's Rocks

Li'Meth is the most northern of Keshian ports. The anchorage is reasonably sheltered except with a wind from the south. Surprisingly the people of Li' Meth welcome trade with Kingdom Ships.

Straits of Darkness

Isle of the Esrit
Ranom

Ranom is a small Keshian town. The anchorage is reputed to be adequate. I have never been there.

Queg has a magnificent harbor which I never want to see again. Never enter without a Quegan sponsor and without proper papers signed by a prefect.

Ylith has a small jewel of a harbor, safe and snug in all weathers. Ylith the town is on a peninsula pointing south by west. Rocks and shoals extend south west from the harbor to past the rocky point. A light is shown on a watch tower at the west end of the harbor entrance. Pharos is on the tip of the peninsula. There is a dangerous tidal race that has swept ships onto the rocks, so when waiting for a turn to enter the harbor best to anchor along the sandy beach that streches east by south east of the town. Ylith is the last Kingdom harbor if you are sailing for the Far Coast. Provisions are reasonable, especially the salted beef and the water is sweet.

Sarth a harbor at the north end of the Bay of Ships open to heavy weather from the south west. For a minor harbor it is well maintained and has several docks. The anchorage is 8 to 5 fathoms of water, mud and clay bottom, good holding ground. The harbor shows no light and the lights from the village on the bluff can be misleading so it best to wait for full light before hazarding the habor.

Ylith

Questor's View a promentory used as land mark. View from the SE.

Necklace Islands

Window's Point

False Bay

Sarth

Bay of ships current south east, numerous fishing villages.

Raver's Shoals

Vortinia Bank

Sorcerer's Island

Bay of Ships

Krondor a silly place for a harbor and is fully man made with enclosing moles and break waters. The commercial harbor is to the north; the military harbor is to the south, with a narrow entrance. When approaching the commercial keep the castle on the hill to starboard. At night the watchtower on the starboard side of the channel shows a light. The harbor may be closed at night with chains (at the Prince's whim). The military harbor is closed with chain and boom at dusk. The harbor master is an official boor but the people are friendly.

Krondor

Shandon bay

Port Vicor / Port Vykor a harbor safe in all weathers. At the north end of Shandon bay. Plenty of docks and quays. Several of the larger docks show lights at night. Always a market for lumber and cordage. Keep a close eye on your seamen, other captains are always looking for crew.

Land's End Landreth

Landreth

Durbin

Sorcerer's Island is a cragy island of dread repute. The sole inhabitant is rumored to be a foul necromancer who is as powerful as he is evil.

True North

Never trust charts showing either Durbin or channels through the shoals of Durbin. Wreakers and pirates have been known to ciculate false maps and information.

Land's End a fair harbor with some exotic keshian trade goods to will fetch a good price in the East. Morgan's Ruin can be seen to the south west of the town often before the town itself is spotted.

The Black Castle at Sorcerer's Isle

Entry, the Fifth

AFTER MY BRIEF DAY OF EXPLORING BORDON and making what I could of the opportunity, we gathered on the docks and boarded Talbot Kilrane's fastest ship, *The Storm Queen*. Weighing anchor, we left on the evening tide and caught a freshening breeze out of the northwest, so we had an auspicious beginning to the next portion of our journey. Currents ran swiftly and following winds propelled us smartly along, so we retired that first night confident of a swift passage. As is often the case, Ruthia, Goddess of Luck, is fickle in how she views men's plans.

Captain Abrams had plotted a dangerous course, choosing speed over caution, for most traders used rutters, charts of landmarks along the coast, to follow the shore around the rim of the Bitter Sea, avoiding likely routes for Quegan pirates.

These freebooters were given marques from the Quegan King and were "auxiliaries" in that navy, but while the regular Quegan fleet would respect the flag of the Free Cities, the pirates often ignored the niceties of international treaties. They would lie in wait just over the horizon or heave to in the sheltered inlets of small islands off the coast, so should a ship wander away from shore, or not avoid known places pirates lurked, they fell prey.

More than one ship from Keshian Durbin, the Principality of Krondor, Yabon, or the Free Cities vanished without account, despite clement weather. And some time later items that matched the missing ship's cargo would appear without provenance in one of the many markets, in different cities, somehow eluding customs. It was one of the inherent risks of travel on the Bitter Sea. The trick to successfully navigating the Bitter Sea, the captain told me during the voyage, was to know where not to be as much as knowing where it was safe to sail.

Rough weather overtook us when we were but within a few more days of travel to reach Krondor. We had safely passed south of Quegan waters and were close to our destination when the ship broke through a very large wave, what the captain called a "comber," and the ship shuddered. Even to my untrained ear there was a change of sound in the way the ship groaned as it breasted these large, rolling sea waves, and the captain informed the Duke we needed to heave to somewhere sheltered at once, else we risked sinking. So he turned the ship around and made for the closest safe harbor, the southern side of Sorcerer's Isle.

A PRIMITIVE MAP OF SORCERER'S ISLE found among Macros's belongings. Artist unknown.

Sorcerer's Isle was a place of dark legend, one avoided by trading ships and war vessels alike, home of the most feared man in the world, Macros the Black. As I write this, I struggle to look past my many memories of the place and the man and remember when he was a shadowy legend, a storied figure to fill a boy with dread at even the most remote chance of meeting him, or visiting that island, a place to fill a boy with foreboding.

When the captain informed the Duke that we'd be putting into Sorcerer's Isle, that was the first time I heard mention of the name "Macros the Black," this time from my master Kulgan's man, Meecham. We limped into the small bay on the southern side of the island, dropped anchor, and hunkered down to wait out the storm. The storm had churned up enough silt and tide that it was impossible for divers to do any work safely on a crack in the hull.

I felt that foreboding as I came up on deck the first time, as the storm's fury had lessened enough I could do so without being drenched. Upon the eastern end of the island rose up a massive spire of rock, upon which sat a castle of baleful aspect. It was connected to the island by an arching bridge of stone and in the tallest tower a blue light glowed, hinting at evil magic and dark powers in residence.

I would learn years later that this was but mummery to keep intruders away, for Macros had claimed this island as his personal refuge. In a future entry I will detail some of his heroic acts and mysterious disappearance, but for now I will attempt to re-create our first encounter as I remember it.

After the storm had broken, Kulgan and Meecham, along with Prince Arutha and Sergeant Gardan, decided to go ashore, to stretch legs as the Prince called it, and I came along.

Even as the sailors rowed toward the beach, one of the few safe landings on that island I learned later, they kept looking up at the distant castle, as if expecting demons to come swooping down off its towers.

The sailors dropped us off at the beach and were instructed to wait by the boat, which was perhaps unnecessary, as Prince Arutha's rank would not have been enough to get them

to accompany us on our exploration of the island. They had been the only ones of Captain Abrams's crew to volunteer to row us ashore, so fearful were the men of the legend of the Black Sorcerer.

This part of the island was thick with nesting birds, plovers, and turnstones, who squawked warnings if they saw us approaching their nesting sites. Kulgan remarked it was unusual to see them this far north at this time of the year, so the south side of the island must be unusually well sheltered for them to be here.

While we were determined to avoid the castle, Kulgan convinced the Prince there was little harm in exploring another trail splitting off to the west and over a ridge. We moved with purpose, the drying ground providing safe footing.

Reaching the first of two ridges, separated by a small gully between, we saw weather to the northwest was clearing, meaning that with fortune, the captain would have the keel repairs completed in good fashion and we would shortly be on our way to Krondor.

Meecham kept his hand on the hilt of his broadsword, and I absently fingered my sling in my pocket as we trudged down one ridge and up another. Gardan was also alert for possible troubles. Prince Arutha seemed unconcerned and moved easily, while Kulgan was already caught up in the moment, his eyes moving constantly as he seemed to be drinking in every detail of the surroundings.

We crested a ridge and found ourselves presented with a view of a small valley, ringed with gentle hills and in the midst of which sat a series of buildings I would come to know well in recent years, but which at that time was a mysterious sight. It was Villa Beata, or "Beautiful Home," in an ancient Keshian dialect that was still heard on the Island of Queg, and a few parts of the Empire of great Kesh.

Upon first spying what would become my second home, along with the Academy I'm constructing on the Island of Stardock, Kulgan quickly concluded the place was currently unoccupied and we proceeded to head down into the valley to investigate.

A FLOOR PLAN of Villa Beata after its restoration.

There was a main building, in the shape of a large square with a central garden—which we couldn't see then, but I came to know intimately later—and in it rested a fountain dominated by a sculpture of three dolphins, which when restored is still one of my favorite places to rest. I noticed outbuildings, but at that time didn't realize one of them was a most amazing bath in the Quegan style, as well as a detached kitchen and two buildings for servants.

The trail was overgrown, but not so thick as to be unnavigable, and we easily reached the valley floor. It was hardly more than a dell at this end, but it opened as we approached the buildings of the villa and saw what might have once been a pasture for animals sweeping away to the right of the main building, with a small knoll on the left side. I remember Meecham handing me his hunting knife, which I took with thanks, yet now I find the image amusing given what I came to learn of this place over the years. At that moment, given who resided on that island, Prince Arutha, his father, and the rest of our party were standing on perhaps the safest place in the entire world of Midkemia, for we were under the scrutiny and care of Macros the Black.

The villa was surrounded by a low wall, not for defense as Meecham observed, but most likely to keep livestock from grazing too close to the house and out of the gardens that had once been carefully tended but now were overgrown with weeds and brambles. Sergeant Gardan also noted the absence of any tower for lookout, and Meecham observed those who once resided here obviously had no anticipation of trouble.

Inside I caught my first glimpse of that ancient statue of three dolphins that dominated the now empty reflecting pool, the tiles once vivid blue now faded with age. It was one of my later joys to replace those tiles and brighten the stonework surrounding it, and return that statue to its former glory, but on that day, as a boy, I merely stood in mute awe of something that spoke of unknown history. Who were the people who built this place and from whence did they come? And why did they leave?

The rooms were empty, save a shard of pottery in a corner in one, or a broken stick of some piece of furniture in another, and everywhere laid the dust of ages. I saw no sign of any inhabitants.

I found Macros in the baths, or rather he found me.

I had separated from the others when it was obvious there was no one living in this place. I found an oddly constructed building, consisting of three rooms and an

A Teacher and a Student at Villa Beata

antechamber, and in each room looked to be a large pool, which I now know to be a bath. A voice from behind informed me of its name, and I turned to see a man dressed in a simple brown robe with a whipcord belt. He had an intelligent look about him, grey hair at the temples of otherwise long dark locks, and he regarded me with deep, dark eyes, as he held a sturdy oak staff.

When I reacted in a startled way, bringing up my blade, he calmed me with a few words and we began a conversation. He identified himself simply as "a traveler," and he gave no other name. We found the others and after introductions, the traveler explained that he had lived at the villa long before and had returned after having been away for several years.

He said some things I now find very amusing. When the Prince wondered how he could have lived here when it was clear this place had been abandoned for a very long time, Macros's answer was that it wasn't that long ago and he was older than he looked, because he ate well and bathed regularly.

When Meecham asked about the Black Sorcerer, he replied that the magician left him alone as long as he didn't trouble him at work. It was a clever answer, though even then I was growing suspicious.

I was tripped as we turned to leave and fell hard against Kulgan who turned his ankle. Macros slipped a small note on parchment into my tunic as he helped me to my feet, which we read at the beach. The note was from the traveler, who identified himself as Macros the Black, and that was but the first of many encounters I had with the man over the years, the first hint that Macros's life was entwined in my fate.

We found repairs nearly complete when we returned to the ship, and the weather turning mild, so with relief, we bid farewell to Sorcerer's Island and turned for Krondor.

That was my introduction to both Sorcerer's Isle and Macros the Black.

❦ *Not much past thirty years of age when he began writing his journal, my father regarded his first visit to Sorcerer's Isle with a perspective of one who had not seen enough time pass to truly gauge the significance of some key event.*

There are several accounts of the main conflicts over the years between my father, with allies, and forces that can only be regarded as pure destruction. The nature of the enemies we faced were not made known to us until recently, after decades of struggle, so it is only now I can look back and appreciate how naive my father was in his youth. It was, in many ways, a charming quality, one that provided him with an openness and acceptance of others I struggle to match, failing more often than not. I'll confess in this one area, I am more like my mother, guarded at best, suspicious at worst, and I take a while to trust people.

For me, there is more than a little irony in several of my father's observations at this time of his life. I benefit from the perspective of more than a century's hindsight, so I try to put myself in my father's place. I usually fail in the attempt, but I do try.

Sorcerer's Isle is my home. It is where I was born and raised. To me it will always be the first place I remember, and to where I will always eventually return, no matter where fate or chance takes me.

At the time of writing his previous entry, my father had returned from the Tsurani world, brokered the peace between the Kingdom and the Empire of Tsuranuanni, watched the betrayal of that peace engineered by Macros, reestablished the peace, and fought the Great Uprising when the false prophet of the Moredhel, Murmandamus, led an army from beyond the Teeth of the World, down into the heart of the Kingdom to attack the city of Sethanon.

My father was married to a woman named Katala, a former slave on the Tsurani world from a nation known as the Thuril. He also stood father to a boy, William, and an adopted daughter, Gamina, and that was the family he knew as he wrote about Sorcerer's Island the first time.

Since then his entire first family had perished, and he met my mother, Miranda, who happened to be the only child of Macros the Black, so you see Macros was destined to be Pug's father-in-law and is my grandfather.

As stated, there is ample opportunity for irony here.

The villa I knew as home was rebuilt by my father and became a second home, while he oversaw the construction of the Academy of Magicians on the Island of Stardock, in the middle of the Great Star Lake, on the border between the Empire of Great Kesh and the Kingdom of the Isles. It did not become his primary home for years to come.

Since my birth our home has been attacked by agents of that darkness that father sought to battle, and at one point it was almost completely obliterated. After the second attack and the death of my mother, Father abandoned the island almost entirely for a number of years, before finally returning to restore the villa.

As one might imagine, it has changed and evolved over the years. At first a home for a small group, a family and some close friends and servants, it has been enlarged and became something very special to my parents, a school for gifted practitioners of magic, scholars, and gifted masters of various arts.

It is a beautiful home, with grace and open space, and unlike any other home I have seen in this world of Midkemia. My mother could be difficult at times, for she had a temper, but she was unstinting in her love of me and my younger brother, Caleb. As with my mother, Caleb no longer lives, but his presence lingers at Sorcerer's Island, as does hers, another reason why I feel more at peace there than anywhere else I have ever known.

Even when my father abandoned the villa on the isle, after the death of my mother and brother, and allowed the ruins to lie untended for years, while those of us who belonged to what is known as the Conclave of Shadows scattered to all corners of the world, even then I stayed on the island.

I have a small house, little more than a hut, on a small beach near the north side of the island, where I used to go to be alone and occasionally fish. Although I knew my father feared for the safety of everyone in the Conclave, his real reason for leaving the house in ruin was he could not imagine it without my mother and brother there. I stayed because I couldn't imagine being anywhere else. At last my father relented, and the villa was rebuilt.

Now trees my father planted as a young man are lofty and offer sheltering shade from the heat, cut the bitter winter's wind, seem to stand as sentinels against the world's unwelcome intrusions. My father and I both had duties that took us many places over the years, but this is where we always returned, and as I age and consider the burden fate has put on my shoulders, I cannot imagine there is anywhere else I would call my home.

Entry, the Sixth

WHEN FIRST SAILING INTO THE HARBOR AT KRONDOR, I was visited by a sense of awe that in retrospect was more a function of my youth than the city's magnificence. Twice before I had been visited by the same amazement that a place could be so large, so different, teeming with people: my first visit to Carse, and my first visit to Bordon.

Here, years later, I realize that I have witnessed wonders and seen sights that no one else on Midkemia has seen, the beauty of Rillanon, the majesty of Kentosani, the Tsurani Holy City, the mysterious and staggering City Forever. But to a boy fresh from the Far Coast, thinking erroneously his journey was coming to an end, this was a most marvelous place, for it was *the Prince's city*!

Since my first visit I've had occasion to visit Krondor several times, and my appreciation of the city has changed. Krondor is one of those places one comes to feel comfortable with, yet in its own right possesses little to recommend it.

The story is told that Krondor is the Prince's city because the first Prince of Krondor, a younger brother to the King of Isles at the time, had fought his way through what were essentially a cluster of bandit tribes and outlaw warlords to reach the shores of the Bitter Sea. The region to the west of Malac's Cross was a wild no-man's-land.

To the south lay the Grey Range, low mountains that were difficult to pass despite their modest altitude compared to the other great ranges on Midkemia. To the north lay the Great Velt, home to nomadic people who have since vanished as towns and cities were built by the Kingdom, but who at the time hunted the grasslands and would raid travelers.

At that time, all trade between the Kingdom of the Isles and the Empire of Great Kesh was in the east, by ship. The only overland trade of note was smuggling.

History is a little vague about this period of expansion westward. The first Prince of Krondor, Richard, was the younger brother of King Henry II, and had been sent west to quell rebellion among villagers to the west of Malac's Cross, a stretch of rugged frontier that stopped at the foothills of the southern Calastius Mountains. Through an almost comical series of events the struggle turned into a chase up into a pass not yet fully explored by the Kingdom, leading to the region we now know as Darkmoor.

In the Prince's report back to his brother of this portion of the journey, he mentioned an abundance of wild grapes in the valleys on the northeastern foothills of the range, which would eventually become the premier wine-growing region in all of Triagia, Ravensburg.

I've only recently begun to read Kingdom history and find the volumes available to me in both the libraries at Krondor and Rillanon to be of mixed value. Some are genuine works of scholarship, but many are so wildly inaccurate to the point of being fiction. Several are works commissioned by certain nobles or wealthy commoners designed to aggrandize far more than save for posterity anything resembling an accurate recounting of facts.

Chronicles of Richard's expedition to the West are fraught with invention, conjecture, and supposition. The few missives between Richard and Henry provide little amplification for the simple fact that he went well beyond his mandate to put down rebellion in the West and moved aggressively forward to finally plant the banner of the Kingdom of the Isles on the shores of the Bitter Sea.

From what can be cobbled together from various sources, Richard fought a series of battles with various opponents from Darkmoor to Krondor, resting as little as possible before pushing on.

Contemporary records from Salador, the Kingdom's major port in the region on the mainland, indicate that at least four times Richard requested reinforcement. Whether or not he received such, he did continue his movement west.

Here we encounter the most popular tale, myth perhaps, of why Krondor is the capital of the Western Realm. The story follows that Richard fought a battle against a tribe known as the Krondor, a three-day conflict that ended only when he had killed them to the last warrior and entered their stronghold where present-day Krondor sits.

The tale says that at the end of the battle, with smoke filling the sky and his soldiers on the verge of exhaustion, he sat on a knoll above the shore of the Bitter Sea and wept at the most beautiful sunset he had ever beheld, declaring he would build his palace on that very spot. In honor of the tribe he had conquered, he named the city after them, took what remained of their women and children and apportioned them among his troops, ordering his men to marry the very women they had just widowed and to adopt their children.

Despite the unprecedented actions of the Prince, eventually this act of conciliation created the core of Krondor, the capital of the Western Realm. There was an unfortunate series of husbands being murdered by vengeful wives, and young children fleeing the camp, but eventually the situation stabilized, and the outpost the Prince founded grew into a town. The King seemed pleased that Richard had found a land to call his own, as well as giving the Kingdom dominion over that part of the continent. King Henry sent provisions, a company of additional soldiers, and a few volunteers who wished to settle in the West to reinforce Krondor.

By modern standards, the location for what was to become the second-most-important city in Kingdom, the seat of the Principality, was an inferior choice. A far

THIS MAP OF KRONDOR was a gift from Prince Arutha for my collection.

more natural location to the south, in Shandon Bay, or up the coast in what is now the town of Sarth would have been preferable. The harbor was nonexistent at the time of conquest, and dredging took decades to bring it to its current standards. Large seawalls were constructed to keep the harbor mouth protected and defensible, and trade ensued, but no ship's captain enjoyed entering the harbor, as it was always difficult under the best of conditions, and in bad weather few were willing to try it.

Krondor has changed little since I first visited it with Duke Borric, Prince Arutha, and Kulgan. The palace still sits athwart the hilltop upon which the ancient tribal fortress sat, in the southwest corner of the city. To the east a more recent population lives outside the walls of the palace and below the southern wall of the city in one of three faubourgs.

Directly to the north of the palace lies the wealthy quarter of the city, where nobles, rich merchants, and well-connected businessmen reside. The houses in this area are settled on streets carved into the hillside leading up to the palace, and those on the northwest slope have a wonderful view of the harbor and sunset, while those on the eastern slope have a view of the temples and the sunrise. Gardens abound and those inns that are situated on the Sandy Beach Road and on the western side of Broad Street are among the finest on the Bitter Sea.

To the east of the wealthy quarter is the smaller temple quarter around Temple Square where each of the major gods has a full temple, and many local and minor deities have shrines. To the north of that is the merchant quarter, the single largest part of Krondor. It is a mix of businesses and homes, rather than a concentration of commercial enterprises as the name might suggest. The farther north one goes, from the area surrounding Temple Square, past the Merchant Gate up past Miller's Road to the northern wall, the quality of residences falls off, until at last you are moving into the northwest corner of Krondor, the poor quarter. Businesses situated between Sea Gate Road and the poor quarter are often affiliated with criminal activities, and constantly under the scrutiny of the City Watch,

under the command of the sheriff of Krondor. Even those on legitimate business after dark in this part of the city, if untroubled by thieves, prostitutes, or mountebanks, may be detailed and thoroughly interrogated by the watch.

The poor quarter is best visited during the day, if at all, and is the home for every criminal enterprise in the city, despite all efforts to stamp them out. Most criminal activity of note in Krondor is under the control of an organization known as the Guild of Thieves, better known as the "Mockers," who are serving a mysterious personage known only as "the Upright Man." Rumors abound as to his identity, but in fact perhaps as few as two or three people know who he really is.

Outside the city walls lie Fishtown and Stinktown, to the west of the King's Road heading north up the coast. The fishing community lies cheek by jowl with the slaughterhouses, tanneries, tallow rendering, and other trades given to producing large quantities of garbage as by-products of their industries. Given the prevailing winds off the sea, for the most part this is a reasonable location, but when the wind shifts off the mountains for a few days, the poor quarter is even less pleasant a place to be than usual.

In my first visit to Krondor, I had two remarkable meetings, the first being with Prince Erland, whom I found to be a gracious and warm person and for whom I felt an instant liking. More charming was his daughter, still a child at the time, Anita, who inquired if I might be Prince Arutha, for she wished to see him, as she had been informed he was a likely candidate to someday be her husband.

At that time I found the entire exchange captivating, as this very lovely little girl was approaching the prospect of her future with a very serious and determined attitude. As fate would have it, she did indeed become wife to Arutha, but that is another story for another time.

Krondor at Sunset

Entry, the Seventh

LEAVING KRONDOR, WE RODE THE KING'S HIGHWAY toward Salador. By this time I had become a competent rider, and the long journey ahead was not as daunting as keenly anticipated.

Like the Duke and his son, I was fearful of what the coming of the Tsurani to our part of the world might mean, and fearful of those I cared for being threatened. I had gone through a difficult moment when Princess Anita had mentioned that the Duke intended to continue traveling on to Salador then Rillanon. I had found myself missing home, and I also hoped that upon returning we'd receive word of Tomas's fate.

However, a lad traveling farther from home than I had ever imagined, and while Tomas's absence still weighed heavily on me, I found myself keenly anticipating new experiences.

We were escorted by a company of Krondorian Lancers. We would be three weeks on horseback and camp out most nights along the King's Highway.

We halted in the town of Darkmoor, next to the marsh of the same name, due to an unusually heavy snowfall, which lengthened our journey, much to the Duke's ire. As we were all forced to crowd into a single inn, my lord Borric's party and a contingency of Royal Lancers, we were uniformly pleased when the snow stopped. Progress was slow as the horses had to ride through hock-high drifts at times, but after the second day, a drizzling rain helped clear the road a bit.

We rode down from the mountains toward the southern border of the Great Velt, and the weather turned milder. Though cold, it was above freezing and we could move with haste again.

A day was lost when we encountered a large band of outlaws troubling a village, by name Tull's Ford. At sight of the Duke's party, the bandits fled. This relief of the village resulted in the inhabitants insisting we stay for a full day of celebration, and for myself I was pleased. A day out of the saddle and some hot food was welcome. It was a modest meal by the Duke's standards, but it was a reminder of the simple pleasures of home I'd left behind, and I welcomed the opportunity to sleep a night next to a warm fire indoors, even if it was on the floor of a cobbler's home.

The remainder of the journey was uneventful, though I was fascinated by the Great Velt to our north. There were trees and small ponds and other expected woodlands to our left as we rode, but then we'd occasionally follow the road up a hill, where I could see the grasslands sweep away beyond the treetops. I knew from my studies a little Kingdom geography; far to the north lay the Dimwood, a forest as large as all of Crydee, below the foothills of the Teeth of the World.

From where we rode, though, it was impossible to see the Dimwood, unless a trick of the eye lulled me into thinking a narrow strip of darker green on the horizon for a moment might be that mighty forest.

The closest I had seen that endless horizon was the sea on a calm day in Crydee, but even there the water is moving, if slightly, waves and combers and chop, whitecap, and spindrift. The Great Velt lay below the foothills as we would rise high enough to glimpse it, and it was still under winter rain and snow. I have been told that in spring and summer the tall grasses move with the wind, mirroring what I was used to with the sea, but for my first encounter, it was a motionless, ever retreating plain.

We entered wooded foothills for the remainder of the journey; they would rise up to the south to meet the Grey Range, the mountains' border between the Kingdom and Great Kesh. We passed first a smaller road heading south, and one of the Lancers told Master Kulgan it was the cart road leading to the dwarves' eastern stronghold at Dorgin and the Kingdom

Outpost at Duronny's Vale. There was a route through the Green Reaches, a massive forest on the other side of the mountains, that allowed passage up from Kesh if one were brave enough to choose that path. It came out equal distance between Duronny's Vale and the Great Star Lake, where Stardock Island rested, and the garrison blocked one of two possible routes into the Kingdom for raiders and smugglers.

We moved into more rolling pastureland, with small villages scattered about; I wondered what it must have been like to have accompanied Prince Richard on that expedition west from where we were at that moment, for we were entering the region once on the frontier to the southwest of Malac's Cross. The road divided, with a large road moving northeast to Malac's Cross and the other straight on to Salador.

Within a day we were in lands that were clearly pacified for generations, heavy forests having been cleared leaving only light woodlands where the local nobles could hunt. There were large stretches of apple orchards where once primeval forests had choked the land, and woods with small herds of deer to our south, and the many streams we forded or crossed were abundant with fish.

The weather was cold, but not bitter, with rain plaguing us regularly. A day before reaching Salador, a City Guard patrol approached and offered greetings to the Duke and volunteered to escort him to the city. He replied he thought thirty Krondorian Lancers were sufficient protection, then was gracious in praising the Salador City Guards in keeping the area free of brigands.

We rode on.

Entering Salador, I at last understood how rustic Crydee was, even how provincial Krondor appeared to those of the Eastern Realm. Salador was thronged with citizens and travelers, despite the overcast and chilly weather. Many gawked at us as we passed, for we clearly were westerners by my lord Duke's tabard and the Krondorian's attire. Some watchers cheered us, as if they were witnessing a parade. Yet a few muttered to each other,

evidencing disappointment at our demeanor and dress, as if we of the West should somehow be more fearsome or barbaric in countenance.

It took even longer to reach the palace than it had in Krondor, given how much bigger Salador was, but eventually we got there, tired and damp. Our mounts were spirited away by efficient lackeys, and we were led through the entrance to the palace, through a seeming maze of rooms and I realized Duke Kerus's palace was larger than the Prince's in Krondor!

The architecture was so different, for if in ancient times there had been a citadel here protecting the city, it had long been transformed into something far more graceful, luxurious, and less martial. No high stone walls surmounted by palisades or high towers with arrow ports here. Now it was all large halls and galleries, nests of richly appointed apartments for guests, quarters for dozens of servants and a full garrison. We followed a man with a captain's badge, and he led us into Duke Kerus's antechamber.

Lord Borric apologized for any inconvenience but stated the need for quick passage to Rillanon, to see the King. After gently putting aside Lord Kerus's desire to have us stay for a short while, Duke Borric persuaded his host of the urgency of our journey.

They spoke as we walked to the Duke's audience hall. We passed through halls that were decorated in what I would come to know years later as the "Fashion of Roldem," large glass windows beneath vaulted ceilings, several fireplaces placed around the room rather than a single, massive one, and all fashion of tapestry, painting, and fine furniture for the Duke's pleasure, should he wish to entertain one person or one hundred or more.

Kerus's response to Lord Borric's news, shared while we sat at a side table big enough for ten people, was unexpected. While I gorged myself on fresh fruit and sweet wine, I listened to the Dukes discuss the state of politics in the Kingdom.

In my youth I fear I mistook this discussion as merely some issue of standing or rank or some other aspect of politics beyond my understanding, certain to be put aside once

Coats of Arms

TIBURN	**DONCASTER**
THE SPIRES	**KLYDE**
BLACKWOOD	**CLAIRANCE**
GOLDEN WAVES	**VANDER**
STAGHORN	**SILDEN**
SALADOR	**ROMNEY**

Map Locations

- Iron Pass
- Raglam
- Northwarden
- Dencamp-on-the-Teeth
- Kenting Rush
- North Ox River
- THE COUNTY OF BLACKWOOD
- Great Dark Sea
- THE COUNTY OF CLAIRANCE
- Cavell Keep
- THE COUNTY OF KLYDE
- Rock Hollow
- Trapper's Camp
- South Ox River
- Rodric's Deep
- Rom Lake
- Prank's Stone
- COUNTY VANDER
- COUNTY DONCASTER
- Lakeside
- Calinor River
- THE COUNTY OF THE SPIRES
- Miner's Camp
- The Pallasades
- COUNTY CONHOWARD
- THE COUNTY OF BLACKHEATH
- Granite
- COUNTY RIVER RUN
- River Cheam
- THE COUNTY OF THE FORELORN WOOD
- River Rom
- COUNTY STAGHORN
- Romney
- THE COUNTY OF ROMNEY ON THE CHEAM
- THE DUCHY OF TIBURN ON WILDE
- Tiburn
- Sloop
- COUNTY KEARY
- Cheam Bas Tyra
- THE DUCHY OF BAS TYRA
- Ball Hallow
- THE COUNTY OF GOLDEN WAVES
- THE COUNTY OF SILDEN
- Lyton
- THE DUCHY OF CHEAM
- Ferry
- Bas Tyra
- THE DUCHY OF SALADOR
- Ornay
- Cheam
- Seamist
- Northport
- THE DUCHY OF RILLANON
- Salador
- Rillanon
- Bodie
- Timons
- Deep Taunton
- Mallow Haven
- Peaks of Tranquility

WEST

THE SCALE OF MILES
0 25 50 75 100

Map of the Eastern Realm

NORTH

- The Lesser Salnamar River
- Blackwood
- Elma's Cove
- Deer Creek
- THE COUNTY OF RIVER RISING
- THE DUCHY OF RODEZ
- THE DUCHY OF RAN
- Cutter's Bend
- Rodez
- The Grand Salnamar River
- Wine River
- Dolth
- Ran
- Sea of Kingdoms
- Euper
- EUPER COUNTY
- Seaside
- Overhill
- Central Kingdom
- Roldem Isle
- Sadara
- THE EASTERN REALM
- Pointer's Head

EAST

SOUTH

Heraldry

CHEAM	BAS TYRA
RILLANON	EUPER
FORELORN WOOD	RIVER RUN
CONHOWARD	BLACKHEATH
RIVER RISING	KEARY
RODEZ	RAN

PAGES 78–79: THIS MAP OF THE CENTRAL KINGDOM, or the Eastern Realm, was a gift to me from King Lyam, for Prince Arutha told him of my fondness for maps. It not only details those ancient lands of the Isles, but also shows the heraldry of the more prominent nobility of the East.

Duke Borric informed the King of the gravity of the threat. I look back after years of dealing with bitter Kingdom politics, and the even, literally, bloodier politics of the Empire of Tsuranuanni and can scarcely believe how much faith I put in the basic goodness of those in power.

Lord Borric, I found years after this journey, was an exceptional man in so many ways, and then I assumed all rulers must be like him. So much yet to learn, and I was blissfully ignorant of that fact. I discovered the real sources of conflict between Lord Borric and his friend from their early days in court, Guy du Bas-Tyra, and the motivation behind each man in their service to the Kingdom. Both men loved the same woman, Borric's wife Catherine, and that, not politics, was the root of their differences.

After our brief visit with Lord Kerus, we departed for Rillanon. The winds were unfavorable, so the journey took nearly three weeks, instead of the usual two, much to Duke Borric's annoyance. He feared for the well-being of his duchy, and his eldest son, Prince Lyam, and the possibility of a hostile action by the Tsurani.

We sailed into Rillanon harbor on a bright afternoon as the wind drove whitecaps and spindrift in bright sunlight, and I was transfixed. From the bow of the boat I watched as we rounded the headlands and headed north into the bay. Even Salador appeared squat and uninspired next to Rillanon. It was called the Jewel of the Kingdom for a reason. By a combination of accident and design, the stone facing used in the palace at Rillanon was a spectacular colored limestone that gleamed when struck by the sun. King Rodric had decreed that all Rillanon would be redressed in similar fashion and as we sailed into the

harbor mouth I could see that a great deal of work in the public areas was under way. Arching bridges and all official buildings had either been completed or construction had been started, and the view was breathtaking.

I was not privy to all the conversations my lord Borric had on this voyage, or some of those in Salador, and I was still yet a boy with a simple view of things. But I understood enough to know there was a great deal of tension between many of the nobles of the Kingdom, rivalry between the Eastern and Western Realms, and distrust of many of those close to the King by the western lords.

Yet when we were received, it was warmly by the king's Chancellor, Lord Caldric, Duke of Rillanon. He and Lord Borric seemed to hold each other in genuine affection. We were presented to His Majesty, Rodric IV, ruler of the Kingdom of the Isles. The tale of my rescue of the Princess had somehow managed to reach the court before we did, and the King bid me come visit with him alone on his private balcony and recount the story.

I was first struck by how the city glimmered in the noonday sun, seeing it from a completely different perspective than when sailing in. Whatever else the King might have been doing to confound my lord Borric and others over matters I scarcely understood, one thing no one could doubt: he had undertaken to create the most beautiful city on the whole of Midkemia. We spoke of a few things, and he seemed a nice enough man to me. I had difficulty reconciling the harsh things I had overheard while traveling with the Duke.

We waited for the King to make his decision regarding the Tsurani threat, and I was allowed to visit a small part of the city. I was beginning to understand at last that every city is somehow different from all others, despite them being in the same nation. Krondor was important because of its politics, Salador because of its location, and Rillanon because of its politics, history, and location.

Rillanon was as busy a place as I had encountered so far. It was both the capital of the Kingdom and a centrally located port on the Sea of Kingdoms. It was three times the size

Pug Arriving at Rillanon

RILLANON

Major Roads (50')
Minor Roads (20')

1/2 Mile

- Lake Rillanon
- Merchant Fishtown
- Farmland
- Wealthy
- Very Wealthy
- Rillanon River
- Bhannon's Flood
- Embassy's
- Royal Game Preserve
- Poor
- Tanners
- Governmental
- Palace
- Old Keep
- Fishtown
- Poor
- Colosseum
- Pinchot Square
- Amphitheatre
- Merchant
- Red Lion Square
- Doria Square
- Merchant
- Red Light
- Military
- Royal Harbor
- Ishap's Stream
- Commercial harbor
- Docks
- Religious
- Chandler's Square
- Temple Mount
- Temples

of the only other major shipping point on the Home Islands, as they were known, so it was the busiest port in the Kingdom.

Word came the Tsurani had launched offensives into the Free Cities, against Yabon and Crydee, and instantly everything changed. The King became enraged and ordered Lord Borric to return at once to defend the West, placing him under the command of Lord Brucal, Duke of Yabon.

Suddenly we were again leaving as quickly as possible, and I feared now for all those in Crydee, and I maintained as well my lingering concern for Tomas. Whether I would ever see my best friend was constantly on my mind, ignorant as I was at that time of the great adventure he was just but beginning.

The war with the Tsurani had come. Since its conclusion, there have been many accounts of that war from participants, scholars, historians, as well as less reliable sources, but suffice it to say while I played a role, perhaps a major one, in that war, most of the time I was absent from its conduct. I was captured early on in that war and lived for most of it in the Tsurani world, first as a slave, then as a student of magic, and finally as a Great One, a member of their Assembly of Magicians.

Someday perhaps I will write a more personal narrative, but for the time being let me focus on the events of the war, and the importance of that conflict to the Kingdom, and those in Western Realm in particular.

THIS ELEVATION MAP SHOWS the contours of the island as well as the prominent areas of the city of Rillanon. I found it in the library there and had it copied with the King's permission.

Pug Meets King Rodric IV

Entry, the Eighth

THE FOLLOWING IS MY RECOUNTING OF EVENTS to which I was not a witness. Some of it is the product of long conversations I had with Tomas and Prince Arutha after the events in what is now called the Riftwar or the Tsurani War, and the balance is what I have gleaned from official documents to which I have been privy, and discussions I've had with other participants in the war.

To reiterate, I was captured early on in the war and therefore will not attest that every detail here within is accurate, but I believe I have captured the gist of the events under discussion. Not only have I depended on Tomas's and Prince Arutha's own recollections on the matter, but on the commentary of others who witnessed their actions.

From my perspective, the war ended with the first raid through the valley in which the Tsurani had erected their rift machine, a wonder of magic I still study to this day; it was through this device they marshaled an entire invasion force powerful enough to thwart the Kingdom's every attempt at reclaiming that territory, launch a successful incursion into the Free Cities, and turn the eastern half of Crydee into a no-man's-land.

I was captured and for the remainder of the war, nearly twelve years, abided on Kelewan. My life, first as a slave, then as a student of the Assembly of Magicians, then as one of their members, has been detailed elsewhere so I will not reiterate it here.

I had several meetings with Tomas after the war, visiting him and his family in Elvandar, and with his permission on one occasion I asked if I might bring along a scribe who recorded Tomas's recollections.

This is his recollection on the start of the war and aftermath:

"I'm only willing to do this out of friendship, Pug, but for the most part my role in the war was limited. Let me start at the beginning.

"When last I saw you, I was trapped behind the wraith in the mines of Mac Mordain Cadal. I fled and managed to elude the creature. Lost in the mines, not knowing that Dolgan was seeking me out, I wandered, but I felt a tugging in a certain direction.

"It was the great dragon Rhuagh, who used magic of the mind to influence me into finding his home, a vast hall in which treasure unequaled had been secreted. I was reassured, despite his massive size and the reputations of dragons in lore, and learned that at heart he and his kind could be gentle.

"He also led Dolgan to join us and we witnessed his end, for it is a dragon's way to know how many days they are numbered and when comes their end. He had been host years before to the Black Sorcerer, Macros the Black, who gave him a parting gift, a wondrous device that for scant moments revisited the dragon's youth upon him, so that at the moment of his demise he again experienced his youthful glory. It was a sight to behold.

"The dragon's gift to Dolgan was to return the legendary Hammer of Tholin, symbol of rulership, granting Dolgan the rank of King of the Dwarves in the West. To me, beyond my life, was given a suit of armor and weapons, which I know now belonged once to the last of his race, the Valheru, or Dragon Lords, a being named Ashen-Shugar.

"I first became aware of the potential power of the armor when Dolgan and I succeeded in scaring off the wraith that had been following us. Little did I know then the extent of the changes that would occur from that event forward.

"When we left the mines, winter was full upon us, and there was no means by which I could overtake the Duke's party or return to Crydee, so I wintered

at Village Caldara with Dolgan and his people. More gracious hosts I could not have imagined.

"It was in the village I began the vision. At first it would be a fleeting glimpse of an image, or a snatch of sound, voices speaking in languages I didn't know, yet somehow I almost understood. It was the magic in my armor, Pug, asserting itself after ages. Macros later claimed that if not for his arts, it would have overwhelmed me, and true or not, I have no difficulty believing him, for it was powerful magic.

"Dreams haunted my sleep and slowly I was becoming two beings, myself and the ancient creature Ashen-Shugar. In a way I still am both beings, but a struggle within during the war caused me to confront this being, subdue him, and bring his powers fully under my control. At least so far, such is the case. It is one of the reasons I rarely venture outside of Elvandar, for there I am most easily able to stem his rage and desire for rulership. It is the love of my wife and her people that empower me to stay dominant over the ancient power of the Dragon Lord.

"We had conducted six or seven raids against the Tsurani, attacking out of the abandoned mines at the south of the valley they used as their staging grounds. We had inflicted serious losses, but suffered them as well. While each dwarf warrior was the equal of any two or three Tsurani soldiers—and they were fearless—they lacked metal armor, which put them at a severe disadvantage. Still, each dwarf loss was a heavy blow to that long-lived race and we mourned more than a few before that war was finished.

THIS MAP ONCE BELONGED TO A SCOUT DURING THE RIFTWAR. It details the valley in the Grey Towers occupied by the Tsurani, and where I was captured. It was a gift from Earl Vandros of LaMut after I mentioned this project in passing.

The Rift Machine

"We communicated with the others facing the Tsurani using messages carried by the Rangers of Natal. They alone could move through the forests controlled by the Tsurani. The elves were holding strong behind the River Boundary, for their magic was effective against invaders, but they had lost control of the outer forest that had been their dominion for ages.

"Part of Natal was occupied by the Tsurani and they were held in check by a series of natural defenses in the southern territory of the Free Cities, a choke point on the road to Yabon, and had only one assault against Crydee, at the onset of the war. I speculate that part of their concern with Crydee was myself, Dolgan, and our dwarves being at their back should they move against Crydee."

I should add that Tomas was ignorant of the bloody Tsurani politics that were in play at that time, with political factions in the Tsurani High Council vying for position and power, and the Warlord's faction being under political attack by various Houses joining and withdrawing from the war, preventing the Tsurani from any sort of sweeping victory. Had they been able to bring their full weight of arms to bear on this war, it would have been quickly decided in their favor.

"By late summer that first year, Duke Borric had joined Duke Brucal in leading the forces of the West in Yabon, and Prince Arutha had returned to Crydee. His brother Lyam had sailed from Crydee with what men could be spared, joining some elements from Carse and Tulan that sailed through the Straits of Darkness and up to Yabon. The remaining troops from Carse and Tulan held a solid line to the south, preventing the Tsurani from encircling Crydee.

"Further difficulty for everyone was created due to the Tsurani incursion displacing large numbers of Moredhel, the Brotherhood of the Dark Path, who along with their goblin allies were attempting to reach safe haven in the North. To say the situation was chaotic in the early stages of the war is to oversimplify. It was beyond chaotic between the lines, both Tsurani and defenders. Occasionally, the Moredhel and Tsurani ran afoul of each other, to our advantage, and one story is told that Martin Longbow and his companion led a full company of Tsurani into a Moredhel encampment.

"The Tsurani were seasoned campaigners and knew that to stabilize their position they needed to secure their flanks before expansion, so they set about to neutralize them one at a time, beginning with the dwarves raiding out of the mines to their south. They set an ambush, which cost Dolgan's warriors dearly and drove us into the forests to the west.

"We endured a half-dozen skirmishes as we fought our way north, losing twenty good warriors, through the foothills of the Grey Towers, unable to turn to Crydee or circle back to Village Caldara. In the end we found ourselves striking for Elvandar. We reached the River Boundary just as the Tsurani overtook us and I was struck by a poison arrow.

"Upon reviving, I discovered I had been unconscious for three days, and I judge it was the armor's magic that saved me from a painful death. I traveled with three elves, Calin, Galain, and Algavins, to the court of the Elf Queen.

"I had become smitten with Queen Aglaranna since her visit to Crydee the year before, and as soon as I beheld her again, before her throne, I knew something was changing within me. Never could I have imagined how fate would bring us together, and what a painful process would be involved.

*Tomas and Dolgan
Confront the Wraith*

Yet, for all that occurred in the coming years, I could not be happier with the outcome.

"As for the rest of the war, we fell into a pattern. We would leave Caldara and travel north, to rally with the elves in Elvandar, for our combined forces could do much that either group alone could not, and each year I became more the warleader of the combined forces. I told you already of the struggle within where I bested Ashen-Shugar, won the hand of my wife, and became what you see before me, so I will not repeat those stories, but when you at last returned to us, and the war ended, my joy was complete."

I've known Tomas my entire life and trust him more than any other being I've encountered, yet there is something within him, that lingering touch of the Dragon Lord, that makes me certain our roles in the future of this world are far from over. I hope in days to come to more fully understand his situation and, should I be able, to aid him in resolving it.

⚜ *My father's note above, after Tomas's overly modest recounting of his part in the war, was almost a foretelling. Tomas's unique nature was to play a role in the final conflict that began with the Tsurani invasion.*

I repeatedly asked Prince Arutha for his recollection of the early days of the war, and it was more than a half-dozen years after he assumed office in Krondor as Prince, following what came to be known as the Great Uprising, when he finally agreed and wrote the following letter. I was fortunate to get his insights into both the Tsurani invasion and the events leading to the Battle of Sethanon.

Dear Pug,

For the sake of our old friendship and all the service you've provided the Kingdom and my family, I take pen in hand and shall attempt to address the questions you've posed me. As you know, I was surrounded by people of exceptional talent and must stress their parts in the various events I recount, and I trust you will not place too much credit for the successes we achieved on my part in events.

As for my part in the war with the Tsurani, it was for the most part modest. My father had ordered my brother to take ship and come join him, which was to be expected, as Lyam was effectively my father's second-in-command in the duchy. I was relegated to serving in Crydee under the tutelage of Swordmaster Fannon, to my chagrin. I now concede that it was a wise choice on my father's part, given my performance prior to the coming of the Tsurani, for I had never been visited with more responsibility than chasing away a band of goblins or bandits.

Still, as I was young, I chafed under the command of a man whom I considered too cautious and, even dare I admit this, timid. In retrospect, I most certainly would have put Crydee Keep at great risk had I seized every moment to bring the fight to the invaders I saw.

My education in war came slowly at first, then swiftly and brutally.

For the first few years of the war, the Tsurani seemed content to slowly expand their areas of control. They would mount an offensive between two strongholds and then seize and build a new stronghold, expanding their hold in the West in stages. When the Free City of Walinor fell, it was clear they had abundant patience and time was working on their behalf.

Messages sent by Natalese Rangers between Swordmaster Fannon and my father showed that their approach was the same on all fronts, save to the south, where they had dislodged the dwarves from the abandoned mines, and to the northwest, where they feared to cross the River Boundary into Elvandar. In short, we were slowly losing the war.

Then came a spring assault into Crydee, and a siege became an attack. Swordmaster Fannon fell to injury, and circumstance put me in charge of the defense of Crydee. The Kingdom and Duchy of Crydee were well served by many during that period, notably Sergeant Gardan, Squire Roland, Huntmaster Martin Longbow, and a rogue sea captain by the name of Amos Trask, all who acquitted themselves admirably. The full details of that attack were presented in a report I sent along to my father, which you may find in the Ducal Library at Crydee.

—Arutha

The Winds of Dawn Braving the Straits of Darkness

I'm not certain if the above reflects Prince Arutha's notable dry sense of humor or if he really has little to add to the chronicles of those times put down by others. In either case, the above recounting does him little credit.

Although I was not a witness to the events in Crydee during the Riftwar, I have spoken to others who were there, and Prince Arutha's assumption of command and heroism in the face of a determined enemy breasting the defenses of the castle, driving them back by sheer will and example to his men, cannot be overstated. He has since proven himself a leader of men and as intelligent a commander as the Kingdom has seen in generations.

If one were to peruse the many accounts of his leadership both at the end of the Riftwar and during the Great Uprising, nothing written can do justice to the brilliance of the man, both as a military mind and as a critical thinker. More, he was an exceptionally generous man, as his relationship with a young man named James will attest.

Suffice it to say that Arutha's forceful and precise command of the garrison at Crydee denied further expansion to the west to the Tsurani, forcing them to exist for many years in a constant stalemate with the Kingdom and Free Cities. Political forces on the home world, in which I played a part and have detailed in other commentaries, forced the Warlord to launch an offensive that proved disastrous at the end.

I played my part in ending the war, as did many others mentioned, and at the time I felt both pride in my ability to finally bring peace to both nations and worlds, and open trade and communication between what had, for me, become two different homes.

I came to Stardock to build an Academy for the study of magic, on an island bequeathed to me by Lord Borric, who also adopted me into his family so I was Pug the orphan no more but Pug conDoin, cousin to the King by adoption. My wife, Katala, and my son, William, and our adopted daughter, Gamina, reside on Stardock, while I also oversee the reconstruction of the villa on Sorcerer's Isle and attempt to organize these records of Macros the Black.

The Tsurani Attack Crydee Castle

Entry, the Ninth

SO ENDED THE RIFTWAR. We were not, however, done with the Tsurani, for forces unknown to us were moving with dark purpose, and before the end of the war, the Tsurani would become a major factor in our understanding of the threat. What has come to be called the Great Uprising began modestly enough, if you can call an attempt on the life of the King's brother a modest event. The Great Uprising was ended at the Battle of Sethanon, and that came on the heels of several occurrences, journeys, and conflicts that received little notice outside of official reports. The majority of those living in the Kingdom are ignorant of most of what I will detail here, and those living in cities far enough away are even ignorant of the very battle that ended the Great Uprising.

Prince Arutha touched on the events of this period in his reports to his brother, the King, but as is his wont, he was modest to the point of self-effacement and brief in summation to the point of being cryptic at times. Despite being confronted by pressures and fears enough to drive most men mad, he consistently found the means to make intelligent choices and eventually prevail. I began to understand some of what occurred by reading his report to his brother, the King.

One other source of information on these matters was my friend Laurie of Tyr-Sog, troubadour, fellow prisoner on Kelewan, lately husband to the King's sister and newly appointed Duke of Salador. My final source was James, Prince Arutha's squire, the former thief known as Jimmy the Hand.

While Laurie is a storyteller of heroic gifts and has never let the truth interfere with a good story, in this case, with a quiet recounting of events over a shared bottle of good

wine, I think he gave me a fair insight into the events that transpired in this very important but rarely understood conflict.

And Jimmy, or James as he is now called, despite his occasional appetite for flamboyance and a slight tendency to self-aggrandizement, was forthcoming. He told me his tale without embellishment and false heroics. There were enough true heroics for a dozen lifetimes. One thing did become clear: something exists between him and Prince Arutha, and it is more than gratitude for the Prince's elevating him to a station undreamed of mere months before. Rather, it's a profound loyalty and devotion, as a boy might idolize an older brother, or even a father perhaps, but James is driven by two things: clearly, a desire to excel in all things he attempts, and a profound need not to disappoint the Prince. I think he is also coming to be like Arutha in another fashion; he's developing a sense of his place in the larger scheme of things, that the Kingdom is more than a rolling countryside, lines on a map, or the politics of the moment, but rather is something worth defending, an ideal that even the lowest man has a place that can be defined not by his station in life, but by his accomplishments.

Much has been recorded, both in historical documents and a few heroic dramas and poems around the theme of these events, of what has come commonly to be known as the "Search for Silverthorn." My part in this particular series of events was limited as I was on a search of my own.

The Pantathians, a race of serpent beings about whom little is known, were behind all the events that followed. For reasons only partially clear, even now, they determined to raise an army to invade the Kingdom. It wasn't until the end of the struggle we realized they were the major designers of this chaos.

A false prophet of the Moredhel arose. He called himself Murmandamus, taking the name of a legendary chieftain, the last to unite all the clans of the North, and organized the armies of the Northland, dark elves, goblins, renegade humans, and others, to invade the Kingdom. In preparation, however, he felt the need to fulfill a prophecy, that the "Lord of the West" would die.

Somewhat arbitrarily, he judged Prince Arutha was that person, though in retrospect there were any number of people who would have served and inspired the rising of the armies of the North. It is now after the fact that I assume this needed killing of a potential enemy was but a ruse, yet ironically it proved the root of his undoing. Had Murmandamus simply marched his army south without warning, it is unlikely the Kingdom would have reacted in time to answer his aggression. Whatever the case, the attempt on Arutha's life set in motion a series of events with global repercussions.

Using a series of go-betweens, the Pantathian Serpent Priests arranged for repeated attempts on the Prince. First a member of the Guild of Assassins, the Nighthawks, was foiled in his attempt when by chance he encountered Jimmy the Hand, a lad who had made acquaintance with the Prince during the war with the Tsurani. Arutha had come to Krondor seeking aid in the war to discover Guy, Duke of Bas-Tyra, had taken control of the city in the King's name and had subjected the Prince of Krondor to house arrest. Jimmy played a key role in getting Arutha to those hiding Princess Anita, and it was there they first met, in a basement in Krondor amid thieves and smugglers.

Jimmy carried a warning to the Prince, thereby achieving two things: first, he changed forever his place in the world, being forced to leave the Mockers, the Guild of Thieves, as punishment for putting the Prince's well-being ahead of his duty to them; and, second, he alerted Arutha to the threat against him and the Kingdom. There is a rumor I have not been able to verify that Arutha personally met with the Upright Man, the leader of the Mockers, and arranged for Jimmy's safe exit from the Guild of Thieves, at no small price. Subsequent events lead me to believe it was gold well spent, if true, for young James appears a young man of exceptional gifts entirely wasted in a life of crime.

A second attempt at Arutha's wedding to the Prince Anita went horribly awry, wounding the Princess and bringing her to the brink of death as the crossbow bolt that struck her was poisoned. Healing priests from every order attended her, and I did what I could, but

*Jimmy the Hand Encounters a Nighthawk
Preparing to Assassinate the Prince*

in the end the best we could do was to slow the progress of a particularly vicious poison, derived from a rare plant called Silverthorn.

Utilizing priestly healing magic to slow the poison's progress, I created a spell of preserving around the Princess's room, not quite stopping time, but slowing it so that one second inside her chambers took a day to pass in our world, giving Arutha time to locate the plant and devise a cure.

The heroics of that undertaking and the resulting events are well documented in other places; I will focus on certain aspects of the journey that have gone unremarked upon. To understand this mission, one must understand the men.

Prince Arutha was, as I have stated, one of the most competent and intelligent men I've known. As a young man, his major fault lay in his relationships with people, trusting few: his father and brother, Swordmaster Fannon, Father Tully, and Sergeant Gardan. Anita made him far more open and trusting than anyone who knew him before he met her would have imagined. Growing up in Crydee, I had seen his dark moods and brooding introspection, an unforgiving critic of those less gifted than himself at times. With her at his side, he was a different man, far more compassionate and forgiving. The thought of losing her changed him beyond understanding; I saw him after effecting the spell to protect her, and I spoke to others after he returned. His mood could only be said to be rage constantly held in check, and it is to his credit he took that rage and made it a drive to save her. Yet at any moment it seemed madness could overwhelm him.

Having now become his squire, James had uncommon gifts and a natural instinct for survival. He was more than clever, however, for he possessed a deep and critical intelligence that first began to emerge during this journey. He also learned to confront his fears and overcome them, lessons that served him well for years after.

Arutha's eldest brother, Martin, the former huntmaster of Crydee until acknowledged by Duke Borric on his deathbed, was in many ways like his brother, but also had a level

of self-reliance few men ever achieve. Being schooled by the elves as a boy, as well as uncountable days spent alone in the forests, gave him a sense of his own capacities and shortcomings few of us ever achieve.

Laurie of Try-Sog was a fine singer with a curiosity that got him captured during the war simply because he wanted a good look at the Tsurani. He became my closest friend during our imprisonment on Kelewan. I was discovered to have magic ability, and as a result was given over to the Assembly of Magicians to master my craft, and Laurie was left as a slave on the Shinzawai estates. Late he was selected to help the eldest Shinzawai son carry a peace overture to the King of Isles from the Emperor. Despite his carefree manner on the surface, he is a man of deep passion and fierce loyalties, willing to risk all for the brother of his love, Princess Carline.

Gardan, captain of Arutha's Household Guard, was as stalwart and dependable a soldier as any man could reasonably wish for. He had a calm capable aura about him that reassured other soldiers and had them strive to be better soldiers to please him, not because he demanded it. He was of Keshian ancestry, one of the few dark-skinned men in Crydee, yet his Duke gave no pause on his heritage, letting him rise on his own merits, for which Gardan was fiercely loyal to the family and cared for the Princes and Princess as if they were his own children.

Leaving on the search for Silverthorn, Prince Arutha and his group rode from Krondor in the dead of night, utilizing misdirection and false trails laid by men chosen for their resemblance to Arutha's party. Should spies be seeking the Prince, parties who looked to be Arutha and his companions left out of several different city gates, one by ship, at several different times during the day and following night. A group even accompanied me, my family, and Kulgan on our way to Stardock, after having spread the rumor that Arutha would be traveling to my Academy to seek further magic help.

So, late the second night, four unremarkable horsemen set out on their way up the King's Road toward Ylith. Gardan met Arutha, Laurie, Martin, and James outside the city

and continued with them. The Keshian ambassador had graciously loaned Arutha the services of his Master of Ceremonies, a tall dark-skinned man who would be seen here and there around the palace, dressed in Gardan's livery, so it would appear the captain of the Royal Household Guard was still in Krondor.

They rode a fair distance before an encounter with four riders along the way told them there were forces out looking for them, so they kept off the main highway and took back roads, game trails, and cart paths through the forests, leading to the mountain road north. It was during this encounter, Arutha and his companions got their first glimpse of the Black Slayers, Murmandamus's half-dead soldiers, who rise again after being struck down. Ambushed on the trek north, Arutha's party fled to the safety of the Ishapian Abbey at Sarth, their first goal on their search for the location of Silverthorn.

At the abbey, the Prince's party was attacked by a demon, a creature of horrible aspect who was sent by dark forces to destroy the Prince. Only the combined magic of the Priests and a well-placed arrow by Martin Longbow defeated the horror.

When later I heard this recounting, I wondered at the summoning of a demon. I realized how little I knew of demon lore and judged it a subject I needed to study. Later when summoned elementals, a primitive form of demons, troubled us at Stardock, I realized it was perhaps more than an isolated attack, but part of something larger.

⚜ *My father was not being ironic, for he wrote the above just after taking stock on many events that occurred during the Great Uprising. As I possess the benefit of many years' more perspective writing this addendum to his notes, I can say with certainty that had Father known of how deeply entwined the problem of demons was with the Pantathians and other elements serving the darkest forces imaginable, he would have abandoned everything he had undertaken, constructing the Academy, rebuilding the villa, recruiting students, exploring the Hall of Worlds, and much else to devote himself to facing the demons and their masters. As fate would*

have it, that knowledge came to him slowly and cost him a great deal in harsh lessons along the way. Since one of the results of things unfolding as they did was my father meeting my mother, I cannot easily say I regret his choices. The prices, yes, but the choices gave me a life, as well as that of my brother, and despite their occasional bickering, my parents had a deep and abiding love for each other.

In the library at the Abbey of Sarth, Arutha learned the source of Silverthorn: the shores of a single lake in the North, by name Moraelin, also known as the Black Lake. It was nestled in a valley in the Great Northern Mountains, not far from the coast, and according to what Arutha found at Sarth, this was the only known location in which that plant grew, which was the reason its poison was so rare and an antidote even more rare. Lacking any other choice, Arutha set out immediately for Yabon and a path north.

Arutha sent Gardan to Stardock escorting an Ishapian monk, Brother Dominic. He wanted the magicians at Stardock to lend their knowledge to the Ishapians in case he failed. Arutha would have gladly given his life to save Anita's.

Along the road they encountered no trouble, and overtaking a small caravan, they blended in as additional guards. Entering Ylith without incident, they chanced upon two men who would play a vital role in the coming quest for Silverthorn, and the Great Uprising.

Roald, a mercenary and an old trail companion of Laurie's, was the first they met, and he was asked to join them, to further enhance Arutha's disguise as one among many mercenaries traveling in the North. During a relatively minor bar brawl, another assassin sought to take Prince Arutha's life. A Hadati hillman, by name Baru Serpentslayer, saved the Prince. He had recognized the Prince from the Riftwar and was curious why the Prince of Krondor was sneaking into Ylith. He followed and was standing in the right place to kill the assassin before he could strike Arutha.

Each man had his reasons for accompanying Arutha north, those facts being recounted in a journal of the Prince's quest, a transcription of one of Laurie's famous ballads composed after their return. As for the accuracy of that story, I can only say that some of the facts do mesh with what I know personally. Roald was pressed into service once he realized who Arutha was, and Baru volunteered as his need to revenge himself upon the Moredhel chieftain Murad intersected with Arutha's need to reach the Black Lake.

To get to Moraelin from Ylith required a bold journey, over the south pass to Crydee, the very one used years earlier by Lord Borric to bring word of the Tsurani invasion. The addition of two seasoned warriors heightened Arutha's prospects for a successful outcome, so he welcomed their addition to his company.

The most common route from Yabon to Crydee is up a road from Ylith through Zun, LaMut, Yabon City, to the town of Meek's Hold, then overland north of the Yabon Forest, to the trading center known as Lakeside, beside the Lake of the Sky. From there the King's Road ends and a travel route follows the Crydee River, also known as the River Boundary, along the south bank all the way to the ford east of Crydee Keep.

Arutha's path surrendered the illusion of safety—for he had already endured repeated attempts on his life—in exchange for a difficult path few would anticipate. Once over the mountains he would cut through the eastern third of the Green Heart, until reaching River Boundary, where he could be sheltered by the elves until he reached the foothills of the Great Northern Mountains. He also would be taking the more direct route.

They reached Elvandar, where they were hosted by the Elf Queen and my boyhood friend Tomas, now her consort. I have heard of this visit by the Prince from several sources, including Tomas, after I returned from my visit to Kelewan. This is what I was told. After taking rest and discussing their mission, they learned the story behind the Black Lake, "the Hopeless Quest."

THIS MAP TRACES ARUTHA'S JOURNEY FROM YLITH TO MORAELIN, drawn based on Squire James's account by a student of mine.

In ancient elven lore, there was a Prince of Elvandar whose betrothed was courted by a Moredhel warrior—this was my first hint that in ancient times there may have been more than outright warfare between the elves and the Moredhel. The Prince's betrothed spurned the Moredhel's advances, who in his wrath poisoned her with a draught not unlike the poison afflicting Princess Anita. He then carried her still form to Moraelin, where he built a shrine to her and laid her to rest within. An

enchantment from a Moredhel shaman froze the dying woman, an aspect to the story I find eerily familiar.

In the legend, the Prince of Elvandar sought a cure, the plant known as *aelebera* in the elf language, Silverthorn to we humans. It grew in only one location, the shores of the Black Lake. So the elf prince found himself on the same quest as Arutha.

But Moraelin was a sacred place to the Moredhel, a place of dark spirits and ancient magic, one forbidden to elves, because of its dark magic and power. The legend concluded with the tragic image of the Prince of Elvandar at the boundary of Moraelin. Unable to enter that dark place, he began walking a circle around it, eventually wearing tracks so deep they became a canyon around a plateau. Legend has it he still walks the Tracks of the Hopeless, for he may not enter the Black Lake, but he will not leave until he finds his beloved's cure.

Arutha determined that as he was not an elf, he would go to the Black Lake and he would find Silverthorn. Before leaving, Arutha was addressed by the Queen's eldest adviser, Tathar, who told him of the lore of the people, that once all elves were as one but the Dark Brothers had been driven away for their dreams of dark power. Here Arutha first learned the identity of the Black Slayers, the armored foes who refused to die from normal wounds, and where he learned of Murmandamus, the legendary leader of the Moredhel clans who appeared to have risen from the ashes of history to return the Brotherhood of the Dark Path to glory.

Arutha and his companions were accompanied by a young elf named Galain, who guided them to the boundary of the Black Lake. After some difficulty, all but Galain crossed a stone bridge to the plateau where a building awaited.

It was clear to everyone this structure was too new to be the crypt of ancient legend and was most likely a trap. Jimmy stole in and saw what appeared to be Silverthorn contained within a crystal sphere. Judging it a more than obvious trap, Jimmy and Martin deduced the plant would grow along the shore of the lake, and perhaps be underwater as the result of heavy rains that spring.

Finding the plant where he sought it, Jimmy presented it to Arutha. The Prince and his companions quickly turned south, eager to get the Silverthorn plant to the healing priests in Krondor.

A band of Moredhel, led by the shamanistic chieftain named Murad, overtook Arutha's party and finally they turned to confront the band of Moredhel and renegade humans. Galain left the party, racing as fast as he could south, to the elven forest, where he could summon aid. Baru defeated Murad and the Moredhel departed while the human renegades attacked. Galain arrived with reinforcements and Arutha made it safely to the edge of Elvandar when the Black Slayers returned and threatened to overwhelm them. Tomas arrived at that moment and destroyed the Black Slayers. After a brief rest with the elves, Arutha returned home to Krondor, where Anita was eventually cured.

I had, in the meantime, traveled to Kelewan to uncover the source of a troubling vision one of the seers at Stardock endured.

My father never did find the time to gather information on his days on Kelewan, nor the other worlds to which he journeyed. I've speculated on why, only to conclude that to my father, Midkemia was always his home, and that many of the memories associated with Kelewan, the Dasati realm, and his travels elsewhere are simply too painful for him to revisit. Moreover, his time spent elsewhere is but a tiny fraction of his time spent here.

I will say this much about my journey to Kelewan; I sought to explain the link between a vision, one given to an old seer named Rogan.

In my training on Kelewan, at the end when I joined the ranks of Great Ones, there is a shared vision, upon the Tower of Testing, in which each magician sees the history of humanity coming to Kelewan. It is different in some ways for each magician; though the general narrative is the same, some details differ. What was significant was that in the lore

*Squire James Finds
Silverthorn in the Black Lake*

of the Tsurani, they came to Kelewan from another world, driven by a massive horror known only as "the Enemy." In the ancient Tsurani language, the word had two meanings, enemy and a darkness so profound it destroyed.

It was that word Rogan the Seer called out when he saw a vision of what was threatening Midkemia. Being at a total loss to explain why anyone on Midkemia besides me would even recognize that word, let alone know its meaning, I embarked on a journey to discover the source of this mystery.

I was joined on that search by Brother Dominic, the Ishapian monk who had traveled with Gardan to Stardock to share what they knew of Silverthorn, and with my old teacher Kulgan's man, Meecham, who was there to safeguard Dominic and me from nonmagical harm. In the end, we uncovered what I thought to be the final clues, but even more important, I discovered a lost community of elves, from Midkemia, living in a secret forest below the ice cap. To the Tsurani, they were "the Watchers," mythical beings, but I discovered they were the Eldar, lost scholars who were the First Servants to the Dragon Lords. They had come to Kelewan at the time of the Enemy and hidden themselves where none could find them, preserving a forest much like Elvandar under the ice near the pole.

For a short time, peace returned to the Kingdom and I was busy about my concerns at Stardock and the Villa Beata. After Arutha and Anita had their first birth, twins by name Borric and Erland, word reached him from the Upright Man that the Nighthawks were once again in Krondor, seeking the death of the Lord of the West.

Investigating the report, Squire James discovered a false Arutha, who with two companions thought they disposed of James and made for the palace. James regained his senses and reached the palace just as the two Aruthas confronted each other. The only one to recognize the true from false was James, because of the sewer mud still upon the impostor's boots.

Enraged that the Guild of Assassins again threatened not only himself, but his family, Arutha ordered everyone on his staff to seek out where the nest of killers might be hiding.

Jimmy used his contacts in the Mockers to discover the Nighthawks' hideout. Arutha conducted a raid against the assassins, but after some successfully fled, the Prince ordered martial law and quarantined the city. While interrogating prisoners, Arutha was struck down by an assassin's dagger, and the city was in mourning. It was later revealed to be a ruse that allowed Arutha the freedom to leave the city and seek out the author of these attacks, reputed to be a Moredhel chieftain and mystic named Murmandamus.

I visited Tomas at the edge of the Elven Forest, outside the boundaries of Elvandar proper and apprised him of what I had learned on Kelewan regarding the vision.

Elvandar is a unique place on Midkemia, for not only is it a forest, it is also home to the elves and the trees that in their ancient language are called *a'tar*, or "star." These trees resemble monstrous oaks but are several times larger, with boles big enough that entire compartments for living can be carved out without harming the life of the tree. Their largest branches can be flattened to provide walkways hundreds of feet above the forest floor, and their leaves glow with marvelous colors, some green, others blue, orange, red, gold, and even white. This gives Elvandar's heart a magic light, a sense of being somewhere else, and with it comes an amazing calming magic. Nowhere else have I seen so many beings at peace with themselves or the world around them than there.

Tomas and I discussed what possible relationship could exist between the threat from Murmandamus and his army in the North, and the attempts on Arutha's life, with the coming of what I only knew to be the Enemy, or in the Tsurani tongue, "the Darkness," and my belief that not only was the relationship of all these things real, but vital.

I then shared with him I had found the ancient elven scholars, the Eldar in a magic forest, under the ice cap on Kelewan. His astonishment was profound and I promised we

would seek to return the Eldar to Elvandar, for their knowledge and magic would bring even more security and wisdom to the elves.

While Arutha was traveling north, I had already returned from my visit with the Oracle of Aal, armed with the little foretelling she could provide, but with enough clues to know where I must next look, among Macros's library—not the one in his castle on the bluffs, but the secret library he had built in the villa.

I convinced Tomas to come with me on a journey, as I needed his arts to travel by dragon to that other world. He summoned a dragon, Ryath, daughter of Rhuagh, and we began our journey. My encounter with the Oracle and the promise to move her and her followers to safety on Midkemia are not a topic I will share in detail here.

It became clear once our journey was under way that the one person who might be able to bring us the knowledge we sought would be Macros the Black. Macros had left a servant, a wise goblin-like creature named Gathis, who had a link to Macros and judged him gone. So Tomas and I began a long search for the Black Sorcerer.

At that time, Martin was home in Crydee, guesting Baru, when word arrived of Arutha's murder. He then received a secret message from Arutha only a few would understand, indicating he was alive and needed Martin to journey to Ylith and meet him. Martin and Baru set out at once by fast horse to ride to Ylith and seek out Arutha.

Arutha left by horse with Laurie and Roald. The behavior of the Princesses Anita and Carline let slip to James that something wasn't as it seemed to be. He then recalled a detail of the funeral—the corpse lacked Arutha's favorite boots—and he suddenly understood that the Prince was alive and calculated what his plan most likely would be.

James and his companion Locklear, another squire in the Prince's court, snuck out of the castle to intercept Arutha. He convinced Aaron Cook, an old smuggling friend, to sail up the coast to Sarth, and after purchasing mounts, he and Locklear found the

A MAP DRAWN BY MY STUDENT, from James's description, showing his and Prince Arutha's separate journeys from Krondor to Sarth, then their journey together on to Ylith.

most likely place to meet with the Prince and his companions and waited. Arutha, Laurie, and Roald rode up the coast and they joined forces. Deciding he had no other recourse than to permit the two young squires to continue with him, Arutha gave his consent.

Reaching Ylith, where they were joined by Martin and Baru, Arutha made his intentions plain, to go into the Northlands to find and kill Murmandamus, ending his threat to all Arutha held dear. The Prince was ignorant at that time of much larger forces involved and didn't realize his plan was overly ambitious, but it did start a chain of events that proved critical to the ultimate survival of the Kingdom.

Tomas and I flew across the sea to the continent of Novindus, a sprawling mass of land, home to many city-states and local warlords. Nestled in the largest range of mountains there, the Ratn'gary, in the foothills next to a deep forest, rested the Necropolis, the city of the Dead Gods. From there Tomas and I entered a magical trance and ventured into the Hall of the Dead, seeking Macros the Black.

Some details of that journey I may not share, but this I will say, in the Hall of the Dead we confronted Lims-Kragma, the Goddess of Death, who assured us that Macros was still among the living. She provided us with clues that led us to conclude that given Gathis's link to his master, and Gathis's feeling that his master was "absent," there was likely only one place Macros could be, a legendary place outside of normal space and time, the City Forever.

Arutha heard of a gang of renegade mercenary engineers was moving northward, contracted to join with Murmandamus's army. Using guile to break the contract between Murmandamus and the engineer general, Arutha moved north, he and his companions playing the part of mercenaries, seeking the false Moredhel prophet.

Following the King's Road out of Yabon City, they moved northward, then away from the road to Tyr-Sog, toward the Inclindel Gap, a narrow roadway, little more than a steep crevice with a flat path in some places, but the only way through the mountains leading to the Northlands, in the Western Realm. There were three major passes in the East, all guarded by the Border Barons' garrisons, Highcastle, Ironpass, and Northwarden. All were guarded by patrols, to keep renegades and weapons runners from reaching the Northlands, but the Inclindel was poorly guarded. Here Arutha moved out of the Western Realm into the Northlands, where the Moredhel resided in numbers, and where the Prince hoped to find Murmandamus.

Along the way they found a dead man guarded by a massive dog, a breed Baru recognized as a Beasthound thought extinct among his people. Continuing north from there,

MAP THAT SHOWS the entrance to the Inclindel Gap.

they were captured by a band of strange soldiers who spoke a language akin to what Baru's people, the Hadati, spoke. They were taken to the city of Armengar, once the ancient Moredhel city of Sar-Isbandia, a heavily fortified city atop which sat a massive citadel set hard against towering cliffs. Here, a series of surprises awaited them.

First of those was the presence of their old friend Amos Trask, absent since the day of Lyam's coronation. Even more shocking was the identity of the Lord Protector of Armengar, Guy du Bas-Tyra, the former Duke of the city that bore his family's name.

Amos told the story of stealing the King's ship to go raiding along the coasts of the Eastern Kingdom, but of running afoul of goblin raiders while anchored too close to shore. He had also discovered that

Pug and Tomas Confront the Goddess

THE THIRD MAP drawn from Squire James's narration, showing the final leg north to Armengar.

Guy du Bas-Tyra had secreted himself aboard the ship, hiding from the King, as a result of Guy's perceived treason against the Crown. They were taken up into the Northland, to be sold as slaves, when they ran afoul of a party of horsemen from Armengar, who freed the slaves. Guy and Amos have stayed in that city, fighting against the dark elves, and had earned the respect of the previous Lord Protector. He had named Guy his heir, and while many in the Kingdom might doubt Guy's loyalty, no one could say ill of his skills as a general.

The citizens of Armengar were kinsmen to the Hadati, who had fled over the mountain rather than submit to annexation to the Kingdom when it first conquered Yabon.

Now they were a fading culture, constantly at war with the Brotherhood of the Dark Path, and faced obliteration at the hands of Murmandamus and his army.

Arutha quickly realized his plan to find Murmandamus was wholly inadequate and lent himself to the defense of the city. He sent Martin, Laurie, Baru, and Roald back to Yabon to seek aid. Roald gave his life heroically so that the others could escape.

Armengar sat upon a naturally occurring source of naphthaline, which when combined with other materials formed a vicious oil known as "Quegan Fire," a substance that once alight could not be put out with water—water only spread it faster. As a last-ditch defense, those pits were fired and the entire city of Armengar was lost in an explosion so fast and terrifying that no one there has provided me with a description that did that event justice, from what I can judge. The good result of that terrible battle and horrible retreat was Murmandamus lost a good third of his army.

The citizens fled through the Inclindel Gap into Yabon, but Arutha and his party, along with Amos and Guy, were cut off after encountering a force of dwarves from Stone Mountain. Martin's old friend Galain had come to lend aid. Cut off from the dwarves by a surge of goblins, Arutha and his remaining friends were forced to flee east.

After Armengar fell, Arutha and his company reached the Edder Forest, where they encountered a race of elves unknown, the Glamredhel, or "Mad Ones," in the elven tongue. An ancient foe of the Moredhel, the Glamredhel agreed to let Arutha and his party continue on their journey.

Reaching Cutter's Gap, the first major passage through the Teeth of the World, the Prince and his party were intercepted by the men of Lord Highcastle, the Border Baron responsible for defending that pass from the north.

Baron Highcastle refused to accede to Arutha's demand that he strip his garrison and flee south, having sworn his oath to the King alone. It was to the Baron's credit that he defended his position with his life, but in the end, Arutha and the survivors

Armengar

of Highcastle were forced to flee south, through the Dimwood, to the city of Sethanon.

At this point Tomas and I, along with Macros the Black, returned from our own difficult journey. We had gleaned the nature of the threat and knew the goal of the invading army was Sethanon.

Beneath the city's lowest basements and cellars, below the sewers of the city, far below even the deepest well, a cavern of vast size and ancient origin awaited. Here the Dragon Lords secreted an ancient artifact of power called the Lifestone. What that artifact may be is still beyond our knowledge. Perhaps someday we'll fully understand it.

But what challenged us for possession of the Lifestone was a combination of forces unimaginable to

THE LAST MAP drawn from James's recounting, of the journey south from Armengar to Sethanon.

any mortal just months before. The Dragon Lords had created the Lifestone out of pieces of their essence, as a tether to return to Midkemia from their exile after the Chaos Wars. By means still not clear, enough of their might existed in another dimension that they could open a rift and project through the physical incarnation of another Valheru, Draken-Korin, a blood enemy of Tomas's Valheru heritage as Ashen-Shugar. More, the architect of this madness, Murmandamus, came as well followed by a Dreadlord, the most powerful of the Children of the Void.

Battle was joined. The military conflict in the city was fierce. Baron Humphry of Sethanon, while hardly battle-hardened, turned command of the city's defense over to Guy du Bas-Tyra, aided by Squires James and Locklear, Amos Trask, and the surviving soldiers from Highcastle. The battle was close and only Guy's brilliance as a commander and the bravery of the city's defenders prevented Sethanon from being quickly overwhelmed.

While the struggle in the city raged on, I waited in a vast and ancient cavern far below the deepest basement dug by man. With me were Prince Arutha, Tomas, Ryath the dragon, and magician allies Kulgan, Elgahar, and Hochopepa. This ancient hall had been excavated by the Dragon Lords, and was protected with a magic spell that shifted time slightly. For while the battle unfolded above, we knew that the true goal of the invading forces was this centuries-hidden chamber and the Lifestone left there by the Dragon Lords. The true nature of the Lifestone was unknown to us, for while Tomas possessed the memories of a Valheru, Ashen-Shugar alone among the Dragon Lords had nothing to do with its fashioning. He knew it to be a device of power, but beyond that was as ignorant as I.

Fate, the gods, or some other unknown agency conspired to have the proper defenders in place, for as Arutha and I anticipated, Murmandamus appeared within the chamber, using arcane arts alien to me. Arutha and he instantly took arms against each other and the contest was close, for while Arutha was the better swordsman, Murandamus was

Arutha Battles Murmandamus

THE CITY OF SETHANON, before it was destroyed in the Great Uprising. The map was found in the library at Krondor.

physically more powerful and possessed magic. Only a talisman given the Prince by the Ishapians at Sarth protected Arutha from the moredhel leader's magic.

A rift formed and the combined essence of the long-vanished Dragon Lords attempted to manifest within the chamber, and only my arts, with the help of the other magicians there, kept the rift from fully forming. But two entities did achieve entrance to the cavern: a likeness of a Valheru named Draken-Korin and a Dreadlord. Ryath the dragon engaged the Dreadlord, while Tomas in the guise of Ashen-Shugar confronted his ancient foe.

The battle ended with the utter destruction of the city, and the death of the Baron of Sethanon, but the forces arrayed against us were vanquished. Ryath the dragon suffered grave injury and it was only through magic means she was saved.

After informing the King of the events at Sethanon, Arutha convinced him it was wise to propagate the myth that the city was cursed and relocate the survivors. As Baron Volney had no heir, there was no nobility in Sethanon to object, and the King's wishes were obeyed.

More on this I will not say here, but to note that this was but the first major struggle with very dark forces. Should we be fortunate, we shall not see them again for ages.

⚜ *It is difficult for me to read the above entry, for as I write this we have endured numerous subsequent struggles with those forces he describes. I will let this story unfold as my father intended, but I have the luxury of seeing the entirety of the Riftwars and my father's chronicle from hindsight. My father writes in a matter-of-fact fashion, about events that would terrify most men to helplessness, and it is my wish here that anyone reading these passages not be lulled into discounting the horrors and destruction he faced without hesitation.*

Entry, the Tenth

AT THIS MOMENT, ENOUGH TIME HAS PASSED since the battle at Sethanon to reveal a few more secrets about the battle, and to further comment on other matters, especially the evolution of our community at Stardock.

First, on the matter of the Oracle. The Aal are the oldest beings known in the universe, a sentient race that became aware almost immediately after the creation of all things. It may be that their origin so close to creation gave them a different perspective on time than other races, but they have among them those who can judge the probability of outcomes so accurately they are said to see the future.

My bargain with the Aal was to find a safe haven for their Oracle, the last living female presence, and her attendants, a dozen males, away from their home world, which verged on destruction. After besting the Dreadlord, the dragon Ryath lay dying, beyond human or elven means to cure. The Oracle was brought to her and possessed her body, for that is the secret of the Aal; they are beings of energy who need hosts.

As Ryath was mindless and near death, I saw no harm in allowing the Oracle to heal her and possess her. One consequence of that act was the use of treasure from the Valheru hoard to repair the dragon's damaged scales. So beyond the normal beauty of a golden dragon's visage, Ryath possessed a patina of gems, diamonds, sapphires, emeralds, rubies, and other precious stones that caused her to be bathed in a breathtaking glow of brilliant colors when struck by light.

She resides there now, and if the means are known, one may avail oneself of her skills as an oracle.

Since the fall of Murmandamus and the rejection of the spirit of the Valheru entering our realm, I have focused my energies on building the Academy at Stardock.

After I had returned from my captivity on Kelewan, I learned that Lord Borric had bequeathed to me a deserted island in the middle of the Great Star Lake. Legend holds that it was formed by the impact of a falling star, hence its name. Whatever its origin, it is an ideal location for my Academy of Magic.

The Great Star Lake sits on the border between the Kingdom and the Empire of Great Kesh, with the Kingdom town of Landreth to the north, and the Keshian town of Shamata on the southern bank of the lake. As a result it was used at times for smuggling, but since I acquired it and began construction, a population of lively young magicians has ended the smuggler's trade.

One advantage to Stardock being situated on an island is we gain far greater control over who is permitted to visit. We are not subject to infiltration of people who might for various reasons choose to do us harm or otherwise compromise the work we undertake. There are still many people, perhaps a majority, who look upon all magic outside of the temples as "evil," and even among the practitioners of temple magic, a few who look upon magicians as somehow perverting the gift of the gods.

And there are the political considerations as well. For all the good magicians did on behalf of the Kingdom during the Riftwar, there is still a distrust of any concentration of power that is controlled by someone else. Kesh's interests are to be certain we are not a tool of the Kingdom, and the Kingdom's interests are to see us continue as a strong ally, or even a subject.

Which has created a touchy situation. Because of my adoption by the King's late father, dubbing me Pug conDoin, and the King granting me a patent of nobility, so I am formally, "Pug, Duke of Stardock," I am considered a subject of the Crown. This obviously is of great concern to the Empire of Great Kesh, irrespective of my attempts to reassure them that the Academy of Magicians will be an independent agency working for the good of everyone on Midkemia.

King Lyam, Pug, Tomas, and Prince Arutha Meet the Oracle of Aal in Dragon Form

To the other nations, Roldem, the Eastern Kingdoms, we are a faceless, nameless potential threat, so efforts must be forthcoming to ease their concerns. Roldem especially is reasserting its independence and becoming once again a factor in regional politics. It has a young, strong King who has spent liberally to rebuild its navy, moving it firmly out of Kesh's shadow. Culturally, the Kingdom of Isles and the Kingdom of Roldem are closely related, with similar roots in the history of the Sea of Kingdoms, and there has been much concern since King Lyam wed a Princess of Roldem.

My efforts to make the Academy welcoming to any magic user from any nation seem to have mitigated all these concerns only a little. I am also building the Academy as a structure that may be expanded. At present it's a relatively tidy three-story edifice, but I have borrowed a design from the Assembly of Magicians on Kelewan, then refined it so that new structures can be added on with a limited amount of demolition for existing structures.

Since my father's writing, Stardock had a complete divorcement from the Kingdom, and we hold ourselves an independent agency. We number as many students and practitioners from outside the Kingdom as within. Roldem's navy has ensured she returned to a position of independence not seen for a century, the Eastern Kingdom's political stances have shifted violently, and all count Stardock as an independent force for good in the world.

My father's anticipation of the need for growth was well reasoned; since the Academy was begun we've expanded. It is now roughly five stories tall and we most likely will see the need to expand again in the future. One thing my father didn't anticipate was the need for support staff; with the students and masters, in what is loosely now becoming something of a Guild of Magicians, devoting time to study and research, we needed to hire others to cook, clean, and take care of all the daily needs of the members. There is now a lively little town grown up around the Fishing Dock, and roads have been engineered from the Commercial Dock,

THE ORIGINAL MAP OF STARDOCK, after the foundations for the Academy had been laid and the village had sprung up around the fishing dock. Drawn by a student.

where goods from Landreth and Shamata arrive to Stardock Town, near the fishing village and farmers' fields, up to the Academy proper.

Stardock was my father's dream and I work to ensure it stays what he envisioned.

Section II

CONCLAVE, DARKWAR, AND DEMONWAR

Entry, the Eleventh

IT HAS BEEN SOME YEARS since I addressed this project, and there is still a great deal of material to be organized and annotated. In rereading what I've written so far, I realize I have tangentially mentioned both the Empire of Great Kesh and Novindus in passing, without attending to the organization of materials concerning those places and others.

While Kesh has been a major player in the politics of this world, my first visit to the Imperial Court came years after events that did bear significant impact on my life and my family's. It is an important story concerning Arutha's twin sons, Borric and Erland, and how they came to change the future of two nations.

To begin, let me contrast the Kingdom and Kesh as an introduction into Kesh's diversity. The Kingdom, along with Roldem, is the result of very like people intermarrying, making war, and conquering one another until political entities emerged. Roldem has its navy as its bulwark, and the Kingdom has its army and navy. But at heart, both nations are populated in the main by people of common ancestry. The Kingdom's first adsorption of unlike people into its borders was the westward conquests of Prince Richard. The tribes conquered in the mountains between Malac's Cross and Krondor were small and their cultural identities were lost within a generation or two. The population along the shore of the Bitter Sea from Krondor to Ylith was space and mostly a few tiny Quegan enclaves and fishing villages, also quickly absorbed.

It wasn't until the conquest of Yabon that the Kingdom really encountered an alien culture. Much of that has blended over the years, and while the Yabonese are a distinctive culture with their own patois, music, and art, they also are Kingdom due to generations of being within the borders. The LaMutians are the notable exception to this due to the large influx of displaced Tsurani warriors after the Riftwar.

Kesh on the other hand began as an aggressive tribe of hunters, the original tribe of Kesh, with a home on a plateau overlooking what is now the greater City of Kesh, on the northern shore of the Overn Deep. As one can see from this map, the immediate area around the great lake is labeled "Keshian Trueblood," and that is a critical difference between the Kingdom and Kesh. For in the Kingdom, a man may rise as far as his talents can lift him, but in Kesh, there is a limit if one is not of "true" Keshian ancestry.

The Trueblood Keshians' advantages were a combination of things, including a wealth of raw materials in the Guardian Mountains, and the Dark Haven Forests, coupled with a supply of domesticated animals. While a hunting culture, they were not nomadic, like the Ashunta or raiders like the Brijaners, and they prized industry and innovation. They used a mix of military conquest and economic subjugation to create the Empire of Great Kesh, north of twin mountain ranges, the Girdle of Kesh, the western range known as the Belt, and the eastern known as the Clasp.

To the south of the Girdle, loose tribal alliances and small city-states existed until Kesh's invasion and subjugation. In the West, the Isalani region is the most pacified, but the balance of tribes and people, known collectively as the Keshian Confederacy, stage revolts and revolutions on a regular basis.

I suspect the best place to begin speaking of Kesh would be to relate my experiences with the twin Princes, Borric and Erland, Prince Arutha's sons, and Barons Locklear and James.

As mentioned before, Baron James was the former boy thief Jimmy the Hand, taken in by the Prince for his service. He had repeatedly demonstrated the wisdom of that choice by serving Arutha as loyally and effectively as any member of the Krondorian Royal Household.

Baron Locklear was the son of the Baron of Land's End. It was a relatively new barony, or rather Locklear's father was a new Baron, the previous Baron having died without legitimate heir—there was a bastard son, but the Crown denied his claim.

Locklear was an interesting youngster, about the same age as James and my son, William. William and I are somewhat estranged as I write this, as he chose to abandon his studies for the life of a soldier.

⚜ *I feel the need to add this comment: my father and my half brother, whom I never had the honor of knowing, loved each other deeply, but my father's idea that somehow William would follow in his footsteps and become leader of the community at Stardock was his idea, not William's. William's gift was the ability to speak with and understand a wide range of animals, and having met others with that gift, it's marginal magic to say the least. Most of the time animals have very little to say of interest to humans. But Father mistakenly believed that William would somehow grow into a master magician.*

I think William and my father's estrangement, and my natural ability, made it easy for Father to accept that my younger brother, Caleb, had no abilities with magic. It took decades, but Father finally realized that magic came to some and not to others, irrespective of heritage. With my parents it would be easy to expect all their children would become masters of the magic arts, but as William and Caleb proved, such was not the case.

Locklear seemed an interesting contrast to James, for though they had very different childhoods, in some ways James appeared to be the more thoughtful, considerate young man. Locklear was charming, especially around the ladies on the island.

Map Legend

Durbin and the Vale of Dreams	Cosodi
Bené	Lutiri
Keshian Truebloods	Kampa
Ashuntai	hansulā
Benedrifti	Islani
Oshoni	Brijaners
Bingāzi	Jasormir

Place Names

Seas & Waters: Bitter Sea, Sea of Dreams, Dragon Sea, Dragon Mere

Regions: Troll home Mountains, Rainshadow Mountains, Jal-pur Desert, Green Reaches, Pillars of the Stars, Eagle's Eyrie, Spires of Light, The Guardians

Cities & Towns: Krondor, Port Vykor, Sálador, Land's End, Landreth, Dorigon, Buronti's Vale, Li Meth, Durbán, Thomātā, Stardock, Elariel, Ronom, Sálac-Bhak, Jonril, Caralyan, Nar Ayab, Westrio, Khattara, Draconi, Cāliman, haravik, Tarafra, Taroom, Toowomba, Shing Lai, Loranough, Tandowae, Tao Zu, Dong Ti

Ashuntai

Spoken Language: Keshian
Written Language: None

Area: Ashunta, southern Keshian plains

Physical: reddish skin and dark hair; men's hair is drawn back into a long ponytail leaving two long earlocks left free – later they appear with scalp locks (central stripe of hair) kept erect with wax; women's hair is left hanging loose

Clothing: no standard for men, though it appears that leather might be popular; no clothing for women, occasionally chains/ropes for them to be led around by

Taxable Goods: taxes on the Ashuntai are light as part of a treaty that ensures large contributions of fine horsemen to the cavalry; otherwise, their horses are second only to those of the desertmen of the Jal-Pur, and they provide average-quality slaves

Other: consummate horsemen, proudly hold to their cultural heritage; they seem to be given great leeway because they were very hard to conquer, and at the time of writing they contributed a lot of crack cavalry to the army of the Empire. Hunting with hawks and eagles is considered the height of manhood.

Important Notes: It is very important that no female Imperial Assessors are sent to assess this people - they regard women as being sub-human, do not permit them to wear clothes, and do not respond well to women in positions of authority. A naturally warlike people, their taxes may be on the light side, but they make up for it with conscripts for the Imperial cavalry.

The Princes, Borric and Erland, where to begin? They possess their mother's coloring, reddish-brown hair and light complexions, pale blue eyes, and their father's look, slender, fast, and strong. Their features are a cross between both parents, and by any reasonable standard, they were handsome young men.

Which was superfluous given their uncle was King of Isles, for had they been hideous in appearance young women from all walks of life would still be vying for their attention. When they stopped to visit on the way to the Empress of Great Kesh's Jubilee, I had a chance for a quiet conversation with Baron James, and he acquainted me with Prince Arutha's desire that his sons be schooled in the responsibilities of their offices. And he informed me that Lyam, lacking a son, would name Borric the Heir, as Arutha had already informed the King he would step aside in Borric's favor. Having twins in the royal succession is always a difficult situation, for it would take little for those with political ambition to line up behind Erland and claim he had a right to the Crown, so Erland had to be committed to his brother, no matter what. This envoy to Kesh undertaken on behalf of the King was seen as the first step on their road to a royal education.

I hadn't seen the two Princes in some years and was surprised at how much they had grown. Their father had subjected them to a fairly rigorous upbringing, while their mother tended to coddle them.

They had two younger siblings, their sister, Elena, and the youngest, Nicholas. Nicholas had been born with a deformed foot, which resisted all attempts to heal, magic as well as mundane, which is a topic I'll comment on at some future date.

PAGES 142–143: AN ASSESSOR'S MAP FROM THE EMPIRE OF GREAT KESH, a few years after the end of the Riftwar. One of my students found it in the market in Krondor and purchased it for me. How it came to be there is a mystery. The illustration is of an Ashunta rider in winter garb, with a hunting falcon.

The two Princes who stopped to visit with me had a well-earned reputation as wild young men. If memory serves, they were roughly eighteen or nineteen years of age when they appeared on their way to Great Kesh. The two Barons barely looked that much older, despite more than fifteen or sixteen years of age difference.

There is a personal note to add to this narrative. It was during this visit that my daughter, Gamina, first met Baron James. It was not merely that they met, they eventually wed. The circumstance of that meeting is, perhaps, somewhat instructive on how these two people became among the most important people in the Kingdom for years, yet about whom very little has ever been recounted.

⚜ *My father is correct. My stepsister by adoption, and her husband, both have been meticulously excluded save for a few superficial mentions in the annals of the Court in Krondor, and in Rillanon. Most of the mentions are due to the role assumed by Baron James, later Duke of Krondor, then Duke of Rillanon, and the creator of the King's spy network. Of my father's life before my birth, I know only what I've been told, but over the years I have come to appreciate his life was in ways far more complex than appear in a simple retelling of facts and dates. His first wife, Katala, William's and Gamina's mother, was dying, and no magic or healing undertaken seemed to do more than slow the disease's progress. There are bitter realities in life, most being the feeling of helplessness that grips us when confronted by something beyond our abilities to mitigate. Doubly so when it involves people we love. Years later, after these events, my father speaks little of his first wife. As much as he loved my mother, in ways difficult to imagine, I think he never recovered fully from Katala's death and his inability to save her. You will notice in the following that he barely speaks of her again. I think years after the fact, her loss was still too painful for him to touch on more than briefly.*

Gamina had not been present when the visitors arrived, having gone to the fishing village to help prepare supper for the growing population of children there. We were experiencing our first sudden surge of workers, many of them with small children, and my daughter loved being around the children. Her personal gifts of magic were not the sort that benefited from a great deal of study—she had the ability to speak with her mind across vast distances, as well as read the thoughts of others—so when I informed her that we had guests, she begged to be excused, promising to meet them the next day.

The next day proved to be eventful. I encountered James in the predawn morning the next day. We had met several times before, but as he observed, we had never really spoken much together privately, nor did we know much about each other. I'll wager I knew more of him from his exploits, and Arutha's pride in his protégé in telling those tales, than James knew of me.

We watched the sun rise and spoke of his childhood and mine. I found myself coming to like this somewhat brash young man, which turned out to be a good thing, given the later events of that day. I suggested he might enjoy a morning soak in the hot springs on the west side of the island, beyond a stand of willow trees. It was thick with reeds but had several places one could soak in very hot water for a time. Then a short dash and jump into the lake, a practice I had enjoyed since moving to Stardock many times. I found it a perfect way to start the morning, as did my daughter and my son when he still lived here.

Unbeknownst to me, my daughter was already swimming there, and James and she met for the first time in the reeds. I do not know the particulars of that encounter, for it is something my daughter refused to share with me in detail. Knowing Gamina, and her talents, I can only imagine it was a profound and deeply personal thing, for the end result was the two of them arriving together for the morning meal and James asking for Gamina's hand in marriage. To sum up, after my wife and I expressed a fair amount of concerns, we at last were forced to concede that our daughter, no longer a child, had made up her mind and there was little we could do but give our blessings. Part of my reason, I

will concede, was that at least my wife would see one of her children wed. As my son was off being a soldier in the Prince's guard, I had scant hope he would settle down before my wife left to return to the place of her birth.

James and Gamina expressed a desire to be married at once, so I contacted Prince Arutha and gained royal consent. He also granted to James the rank of Earl of the Court, a rank he was going to bestow after James's return from Kesh, but which he felt was an appropriate wedding present. After a bit of delay, James and my daughter were wed, and with heavy heart I saw them depart for Kesh.

For reasons I will not share here, I had an idea that James might encounter someone who would prove vital to me, a stranger who might need to hear something that would convince him to journey to Stardock and make my acquaintance. So, as we readied for the feast and I found myself alone with James, I said to him the following: "I do not expect you to understand what I'm about to say. But should you ever come to a time when you need to say something upon my behalf, say this, 'The last truth is that there is no magic.'"

That conversation changed not only my life, but perhaps the fate of all Midkemia, for the person James encountered, to whom he gave that message, was a remarkable character from the province of Isalani in the Kingdom. As I had discussed with James, I needed a third influence in Stardock, as the two most dominant personalities among my disciples were two Keshian magicians, Watoom and Korsh, and I had wished to find a Kingdom magician to leave as the third voice, but in the man who came after hearing James's message from me, I found a mind so unique, a vision unmatched; and his contributions to the founding of our society here at Stardock were unmatched by anything I could have imagined.

His name is Nakor.

I will tell more of the Blue Rider, as he styled himself after a lavish gift of a magnificent horse and blue garb, but first I'll return to the departure of the brothers—the two young Barons—and my daughter as they traveled to Kesh.

The journey of the two Princes through Kesh is actually the story of two journeys. And as such tales are prone to, it begins with a silly and somewhat trivial issue.

Princes Borric and Erland had found themselves in a tavern at the Commercial Dock, and in that tavern was a game of cards, known as pokiir in the Kingdom, poker in the Empire. As a result, with the ebb and flow of luck, and with people coming and going, by the morning of their departure, Prince Borric had managed to acquire a rather colorful set of traveling togs, a purple robe and ridiculous red boots, as well as a staff with a light-emitting crystal on top. He had lost most of his armor and his sword during the evening, then won this attire later.

So, this first thing you should know: Borric, Prince of the blood royal of the Kingdom of the Isles, departed from Stardock looking nothing as much as a down-in-the-heels practitioner of street magic.

To travel by land from the Kingdom into the Empire, there are basically two routes, a difficult trail over the Grey Range, from Duronny's Vale to the Keshian city of Jonril, not to be confused with the town in Crydee named after that city. From Jonril the caravan trail runs to Nar Ayab, through the Spires of Light Mountains, to the city of Khattara, to the city of Kesh.

The other route, the one chosen by the brothers and their party, was from Stardock, down the east face of the Pillars of the Stars, skirting the edge of the Jal-Pur Desert to Nar Ayab.

Almost all other trade between the Kingdom and the Empire is by sea, as there are numerous ports on both coasts of the Sea of Kingdoms, as well as trade along the south shore of the Bitter Sea. And, in both nations, there are wild regions like the Green Reaches, the Trollhome Mountains, and others that prevent easy transit.

As fate would have it, both Princes eventually traversed from Stardock to the city of Kesh by the two routes most likely, and least likely to get you there. Amid a blasting sand-

A MAP constructed from James's—now Baron of the Prince's Court—narration of the amazing journey to Kesh undertaken by the Princes Borric and Erland.

storm, raiders attacked the caravan, and while the majority of travelers were to emerge unhurt, Prince Borric was captured by slavers. Because of his attire, the slavers thought him a magic user and placed upon him shackles designed to blunt magic. An unintended consequence of this was to shield Borric from Gamina's attempt to find him through the use of her mental arts.

The party moved on from their search for Borric, determining his fate was up to the gods, and that despite their grief at his disappearance, the needs of state, to be at the

Empress's Jubilee and represent the Kingdom of the Isles, demanded they move on. With heavy hearts, Erland, Earl James, Baron Locklear, and the rest moved down through the border of the Jal-Pur and the great plains to the city of Nar Ayab. From there they were escorted by Keshian soldiers to the city of Kesh.

Borric, in the meantime, had been taken to Durbin, the Empire's major port on the Bitter Sea. Far enough away from the oversight of the central government, the governor of Durbin effectively was a law unto himself. There had been some business there, involving Earl James when he was younger, that had ended with a member of the Hazara-Khan family taking control for a while, but as politics in the Empire is wont to do, control soon drifted to someone with better relations with the Crown, or at least someone close enough to the Crown to influence the decision about who was appointed governor.

So the slavers conducted business as usual, and Borric was herded into a pen. His escape is something of an adventure in its own right, and I expect at some point someone will write that tale in detail, but for this narrative, suffice it to say a combination of wit and luck put Borric and a companion, a beggar boy named Suli Abul, on a boat in the Bitter Sea.

A general alarm had been sounded that a slave had murdered a slaver and a large reward was posted, so many ships were out on patrol looking for Borric. He was forced away from his desired course, back to Krondor, and set sail to the northwest. Borric had spent enough time sailing as a boy that he managed to elude capture, but the boat he sailed in was damaged and he was forced to seek rescue from a Free Cities ship bound for the Keshian port of Farafra, on the Dragon Sea.

Borric's chance meeting put him upon the preferred sea route from the Bitter Sea to his destination; if he couldn't return to Krondor, he was determined to find his way to the Empress's court and reunite with his brother. Farafra is a trading hub, the coastal city closest by land route to the city of Kesh, and a busy gateway into the heart of the Empire. From there it would be little problem to find a caravan bound for the Overn Deep.

THE CITY OF GREAT KESH. A strange and interesting fellow named Nakor produced the map from a rucksack that seemed to hold far more than possible.

Erland in the Imperial Court, and Borric through his travels overland, arrived in the Empress's palace in time, thwarting a plan to wrest the throne of Kesh away from the Empress. Their part to secure the throne and expose the traitors forged a much closer bond between Kesh and Isles than ever before, beginning a period of relative peace that lasted almost thirty years. The one bitter outcome to this otherwise triumphant series of events was the death of Baron Locklear.

Keshian Trueblood Charioteers

It was a very changed James and Gamina who came past me on their way back to Krondor, and we spoke late into the night about what had occurred on their journey. It was a sobering and sad tale in many ways, but also held a note of triumph, for it was clear the two Princes had learned a great deal about themselves as men and about the responsibilities of office.

And with them came Nakor. I suspect in years to come I will have more to say about this unique and gifted man, but for this entry, simply suffice it to say I had never encountered his like. He was a man of prodigious gifts, yet despite his being able to effect magic in a fashion unlike anything I had experienced, he insisted there was no magic, only "tricks." He claims to be a mere gambler, but it was obvious to me within moments of meeting him that he was much more than that.

Nakor proved a valuable ally for Borric when he first met him on the caravan trail from Farafra to the city of Kesh. Between them, the two Princes of the Kingdom had uncovered and frustrated a coup d'état within the Royal House of Kesh. The result of their actions did two things worth note beyond the personal heroics displayed: it stabilized the Royal House of Kesh for a generation; and it brought a relatively long period of peace between the two nations.

Nakor spent quite a bit of time with us at Stardock, in his role as the self-proclaimed "Blue Rider," which had the net effect of blunting the conservative inclinations of two other leaders in the community, as well as creating his own following, who dubbed themselves "the Blue Riders."

Nakor was also a key actor in the events associated with Prince Nicholas's journey to Novindus.

Portrait of Nakor the Blue Rider

Entry, the Twelfth

AMOS TRASK, WHERE TO BEGIN? A legend on the Bitter Sea, Trenchard the Pirate, the Dagger of the Sea. A series of odd circumstances brought him into the lives of the royal family, back during the late years of the Riftwar. His part in the defense of Armengar and the final battles of the Great Uprising have also been touched upon.

I cannot begin to do justice to the man's nature, and his profound change in life. As a youngster, he was a pirate, one of the most dangerous men on the Bitter Sea. In his old age he was an admiral in the King's Navy, and husband to Anita's mother, Alicia, Prince Erland's widow.

I think it best to let the man speak in his own words. These events came nine years after Borric and Erland's journey to Kesh.

Amos had put in to Sorcerer's Isle to tell me of the following events. Amos, Nakor, and the others in his party had stopped on their way to Novindus during the events recounted below, and I asked Amos to stop by after all was done. As circumstances would have it, it was quite a few years later, toward the end of his life when he finally did recount this tale. I asked if he minded a scribe attending, and this is what Amos said:

"As you know, I had settled into a good life. I was given a magnificent ship, *The Royal Dragon*, and a squadron to command and got to spend most of my days chasing pirates, raiders, and smugglers across the Bitter Sea. I also was keeping company with Princess Alicia, Anita's mother. Just before all this business with Nicky, Harry, Marcus, and the rest of them started, we decided to wed . . . I'm getting a bit ahead of myself, aren't I?

"Well, it's all about Nicholas. You know him well enough, I should think, at this point. But as a child, let's say that coddled isn't the exact word, but he was hovered over to a fair degree by his mother.

"His older brothers were pretty rough-and-tumble lads, and they weren't especially kind when Nicky was a wee boy, teasing him about that deformed foot, calling him "monkey" behind their mother's back, and all the usual torment visited upon little brothers by their older brothers. That did change after the twins returned from Kesh, more credit to them for mending their ways, but a lot of what I took to be Nicky's . . . what's the word? Hesitancy? Let's call it that, a need to be calm and think things through, not with the clear deliberation his father showed, but as a way to put things off a little longer. Yes, that was Nicky.

"The first change in him was because of his squire, Harry, son of the Earl of Ludland. He sort of ignited something in Nicky. Brought out a little . . . recklessness. To me it was welcome; I loved Nicky like a grandson, and he needed to get out a bit more. But there was always that foot.

"Well, you know more of that than I, and that comes later in the tale, doesn't it? Anyway, Arutha decided to send Nicky to Crydee; he thought a little frontier living might harden the lad a bit. It was my suggestion, actually.

"In any event, Arutha gave permission. I pulled rank and took command of *The Royal Eagle*, for a supply run to the Far Coast.

"You know most of this part of the story, Pug. You remember our visit to your island on our way to Crydee.

"In any event, it was Nakor's idea for you to meet Nicky, which in light of what came later was a good idea. That bandy-legged little maniac does have good ideas from time to time.

"Now, I have no idea as to what you and Nakor, you and Nicholas, or anyone else said in private, and truth to tell at my age I'm content to know only what I need to know.

"So we said good-bye and off to Crydee we went. This you know.

"You also know about as much as I do about when the trouble came, as I was already gone from Crydee carrying cargo north. A murderous dog named Render and his crew raided Crydee, and bloody work that was. Render was as evil a bastard as I've ever known, Pug, and I've known more than my share.

"There's all that business going back to the Great Uprising, with the Pantathians, and somehow it's all linked. I know when to ask and when not to. Anyway, where was I?

"While Render was hitting Crydee, another band of murderers attacked the new outpost at Barran, and only because my crew was there and the *Eagle* was heavily armed did we manage to come out of that fight in good order.

"When I returned, I found Duchess Briana was dead, Duke Martin broken up and in bed unable to do much but sleep and heal, and his daughter and her best friend abducted by Render along with all the other prisoners from the Far Coast.

"We gathered our wits, and you came and healed Nicky's foot so he could follow after his cousin and her friends. Nicky pulled rank on everyone, and rather than run home to Krondor, he set out to make things right. That's when I knew despite everything else, Nicky was Arutha's son. And when you used magic to finally fix that foot of his, that's when I began to believe the boy might actually come into his own, and we might recover the abducted children.

"By then Calis had arrived from Elvandar, but instead of heading back to the elven forest, he enlisted on his first voyage to Novindus. Hard to imagine

how intimate he'd get with that place in years to come.

"We disguised *The Royal Eagle* as a scruffy-looking pirate ship, renamed her *The Raptor*, and set out after Render, heading to the Sunset Islands. We didn't know what to expect, as nothing I knew of the islands could support a raid of this size.

"We reached Freeport, where I met an old friend, Patrick, now sheriff of Freeport, and he showed me how much had changed. Once a collection of hovels and shacks, Freeport had become a prosperous little town, with proper homes and businesses, almost legitimate since last I visited.

"It was there we found Render, now one of the seven "governors" of the island. I knew all of them, but only one from my youth, William Swallow.

"We figured out Render was working for someone else. It took a bit of trickery, but we got the other captains to understand what a dog Render was, and we negotiated a deal. Rather, Nicky did, clever lad he was, in exchange for our freedom to pursue the captives.

"Render called out Nicholas and Nicky killed him in a duel, then we found everyone associated with the raid started dying in a hurry. So Render's masters betrayed him and everyone else to cover their tracks.

"We discovered the captives had been put aboard a massive black ship bound for the Southwest. I'd seen some maps that Arutha had—I think a few he got from you—so I knew there were lands down across the sea, but no captain I'd ever met could claim to have sailed there. But we set out, taking with us that little girl, Brisa, the source of our information on the black ship, the one that Harry ended up married to.

"So we sailed down to Novindus, and finally found that damn black ship. For three days we chased her. Those clever bastards led us into a channel and

knew the way and we didn't. They had some magic user aboard who rolled up a storm and drove us into the rocks.

"So only thirty-four of us got to shore, below the massive escarpment. Calis was a wonder and managed to climb to the top with ropes, and after a great deal of effort we got everyone to the top of that plateau.

"It was arid but Calis led us to the river. Along the way we encountered what was left of a raided caravan and a sole surviving driver who led us to Shingazi's Landing, something of neutral territory on the Serpent River, a big trading post.

"We learned a bit about the place there, this Novindus, about city-states and warring clans and things that you'd best ask Calis about—he went down there again.

"Anyway, we got down to the City of the Serpent River and found the girls. There was this Overlord, his magic user Dahakon, who according to Nakor wasn't really alive, and there was this woman, Lady Clovis, who Nakor said was the one really running everything, including the raid on Crydee. Turns out Nakor was once married to her, but in a different body, if I have that right. She was working for the Pantathians.

"I'm getting tired, Pug. I'm old and need to put paid to this tale. We located the girls, saved them, and found the reason for the raid. The Pantathians made simulacrums of those they kidnapped. If the two real girls hadn't been standing on the deck next to me, I would have sworn the two we had locked up in

A COPY OF A GOVERNMENTAL MAP commissioned by Baron Harry, the King's Governor in the Sunset Isles, given to me by Prince Nicholas.

Amos Trask Sails the Raptor into Freeport

the hole were the real thing. I don't know magic, but I know evil, and this was as evil as it could be. These were Pantathians, young ones, changed by dark arts to look exactly like the youngsters who were abducted, sound like them, be them in every way. They would have come back to the Kingdom. And they would have brought as evil a plague as you could imagine. They would have certainly arranged to have Nicky infected before he returned to Krondor. This plague could have destroyed the entire Western Realm. We hoisted them all in a cargo net and dropped them into the middle of the sea. It was no easy thing to watch, as they looked human."

Amos finished with a few personal remarks and bid me good night. The old admiral, onetime Dagger of the Sea, died within a few years after this interview, and while Nicholas turned into a great admiral of the King's Navy in his own right, there was only one Amos Trask.

Entry, the Thirteenth

MANY YEARS HAVE PASSED AND MUCH HAS TRANSPIRED since my last entry, more than I can recount briefly, so I may undertake another narrative someday to address everything that has occurred. The short of it is, the Academy has become all I feared it would, another iteration of the Assembly of Magicians, with its politics and secret orders. Only Nakor's influence, creating the Blue Riders, has mitigated it.

So I devoted myself to creating a small, more selective school at the villa. I made public my intention to never again visit Stardock, but I kept my quarters intact, so I could find refuge when I needed it and be left untroubled.

All the subterfuge was to protect family and friends from the Pantathians. I could care for myself, but if they didn't know where I was, they couldn't extort me by threatening others. There is a little known period between Nicholas's first voyage to Novindus and my next narrative that needs to be explained. As I write this, King Lyam is dead and Borric now rules, and his son Patrick, a lad in his teens, is Prince in Krondor since Arutha's death, with Erland as regent.

I have finally come to realize there were larger forces behind the Pantathians. I and others had been routinely dealing with demons over the years, and the link between demons and Pantathians was now clearly established, but toward what end was not clear. More, whatever agencies stood behind that alliance were also unclear.

I believed the Enemy, as the combined life force of the Dragon Lords was called, to be firmly confined within the Lifestone, so while the Pantathians might still be blindly working to recall their lost mistress, the Valheru Alma-Lodaka, I was certain there

A MAP OF NOVINDUS recovered from the Hall of the Clan Lords in the City of the Serpent River.

was far more to this than they knew. There must be other agencies hidden behind the visible actors.

This was a time when several groups were working ignorant of each other, even at cross-purposes at times. I was conducting my own investigations, Miranda had begun to take a hand in Novindus, and then there was Calis.

Calis is unique, the product of an elf mother and a human father changed by Valheru magic. His birth should have been impossible, yet there he was. Calis realized on his journey with Nicholas how little he had understood his human heritage growing up in Elvandar. He also felt committed to oppose the evil he had encountered in Novindus.

Arutha gave Calis a commission as captain in the army, and he formed a special company, the Crimson Eagles, a small band of volunteers. First among them was Robert de Loungville, known as Bobby, who quickly rose to be Calis's second in command, gaining the rank of sergeant.

By the time we come to the story of the invasion of the Bitter Sea by the armies of the Emerald Queen, Calis had been operating down in Novindus for years.

I had laid false trails and traps for anyone pursuing me, which in hindsight may not have been my wisest choice, as I was late in discovering what Calis and Miranda already knew about the situation in Novindus.

It was the journey before the one in which I became involved I should note. I was still in hiding, Calis and Miranda had not yet met, and the situation back in the Kingdom was unstable. King Borric had one son, Patrick, a headstrong teenage boy. Prince Arutha was elderly at the time of Calis and Nicholas's last voyage together.

Before Arutha's death, Nicholas again commanded one of the redressed Kingdom ships, the *Freeport Ranger*, and set off for Novindus. He and Calis had been slowly exploring this continent, exploring it and learning its politics.

On the voyage previous to the one I'm about to discuss, much of the events, such as

Nicholas's sea battle with two ships of the fleet belonging to the Emerald Queen, a running battle down the Vedra River, and the loss of nearly four hundred men under Calis's command—all these events and more were never chronicled as I understand it. I can only speculate that a tragic sense of failure accompanied this expedition, leaving Calis, and Nicholas, both eager to put things behind.

Just prior to Arutha's death, Calis began to reorganize his command. Understanding just how dire a situation he faced in Novindus, he decided on a different course of action.

Duke James had retired as Duke of Rillanon, King Borric's first adviser, and had returned to Krondor, to take the reins under Arutha during the Prince's last days. James's two daughters were married off and his son, named Arutha after the Prince, had just himself been named Court Baron to the King. James's first grandsons, the twins James and Dashel, were on their way to young manhood—taking after their famous grandfather more than even James liked to admit.

With so much in flux in the Kingdom, and my choice to be absent from public scrutiny, it's no wonder Calis felt isolated from support until he at last got the opportunity to sit down with Duke James and discuss what he had encountered in Novindus.

A decade before, a woman calling herself the Emerald Queen had appeared with a small force of hired mercenaries in the Westlands of Novindus beginning a methodical conquest. No nations exist on that continent, so organized resistance to her came late and was ineffectual.

She started by sacking a dozen small towns and ports near the city of Point Punt, below the western foothills of the Ratn'gary Mountains. Her tactics were simple but effective. Once a town was taken, survivors were given the choice: serve or die. Men of fighting age were given weapons even if they had not been soldiers before, and the women and children were left to fend for themselves. Some stayed behind to farm or fish as best they could; others became camp followers to stay with their husbands.

I've inserted a much later map detailing the line of march and conquests by the Emerald Queen as she subdued all of Novindus. —Magnus of Sorcerer's Isle

By the time Calis became aware of her activities, the Emerald Queen had already solidified her hold on the Westlands up to the foothills of the Sothu Mountains and was working her way down through the Riverlands, having conquered the largest city in the north, Hamsa. That war had lasted five years, as the King of Hamsa imported mercenaries from as far away as the City of the Serpent River, but at last, the single biggest obstacle to the Emerald Queen's onslaught fell. Almost a dozen years after beginning her campaign, she had conquered more land than anyone in the history of Novindus. Her army got larger with every conquest, and the rate of her advance was accelerating.

She was moving against the city of Kilbar, when Calis had brought up his Crimson Eagles in a combined force under a man named Haji; they were almost overwhelmed on three occasions and endured over two hundred and fifty days of siege in the city.

This was Calis's first occasion of dealing with magic being openly used in warfare, and only because the King of Hamsa had competent magicians did the conflict endure as long as it did. It is also where Calis met Miranda, who was helping to thwart the Emerald Queen's magic.

When the city surrendered, those mercenaries who were not native to Hamsa were allowed one day's head start to flee. Calis, Bobby de Loungville, and what was left of the Crimson Eagles departed. Rather than escape down the river and be overtaken, Calis fled to the east, striking for the Great Steppes and allies who protected their retreat. Of over five hundred soldiers, Calis returned with sixty.

He returned to Krondor while Miranda kept track of the Emerald Queen.

Calis and James decided the next voyage for information would be completed by a small company of what came to be known as "desperate men," who had nothing to lose.

Entry, the Fourteenth

IT HAS TAKEN ME LONGER TO RETURN to this narrative than I had planned, but life has a habit of providing you what it will, no matter what you had planned, I have come to learn. The war has come to the Kingdom from Novindus, and I have played my part, and much is left unfinished.

Still, as all of what I write about is in the past, it is of no interest to you, the reader, if I recount events from days ago or decades. Where I stopped before was in the matter of Calis's decision to return to Novindus, leading a group of men who had nothing to lose.

Then Arutha died.

There were few alive who remember Krondor before he took the throne. For more than forty years he ruled the Western Realm with efficiency, justice, mercy, and a concern for the complete well-being of all the King's subjects, not just the privileged few. His understanding of the Great Freedom, the foundation of every law in the Kingdom, was that every citizen of the nation, no matter how low a station in life, has rights guaranteed by law, not the whim of a ruler.

Two of the important players in the events to come, barely more than boys at the time but destined to become men of importance, arrived in Krondor at the time of Arutha's funeral.

They were named Erik von Darkmoor and Rupert Avery, known as Roo to everyone. Two young men from the town of Ravensburg, north of the city of Darkmoor, Erik had apprenticed to a drunken smith who had never registered him with the guild and Roo was a street boy halfway to being a full-time thief and confidence trickster. I will comment on their home later, for their vital role in the future of the Kingdom began when they arrived in Krondor.

Erik was the bastard son of Baron Otto von Darkmoor and had killed his half brother Stephan in a moment of anger, and now he and his childhood friend Roo were fugitives.

They fled Darkmoor, thinking to find their way to Krondor and take ship to a foreign port, thereby escaping justice for their crime; it had been a provoked fight, but Erik had killed a noble son, and Roo had been an accomplice, so their choice was understandable, if not the choice of innocent men.

It was years later I discovered Miranda had taken a hand with these two, sheltering them from those in pursuit, disguising herself as an old crone named Meg. She never outright has told me, but I suspect it was a message from the Oracle of Aal that led her to the boys.

⚜ *Indeed, as my father suspected, such was the case. As I now know, the Oracle was a key figure, far more important than we knew, my parents and I suspected, who was the true conduit for controlling most of us opposing forces of Darkness.*

Much of what I relate here came to me from a variety of sources. I had introduced King Lyam to the Oracle, and every royal knew of her existence, so immediately after Arutha's death, a message reached Prince Nicholas in Krondor as he waited for his brother, King Borric, to arrive for their father's funeral. The message contained two warnings: first, that forces were moving that would eventually bring harm to the Kingdom; and, second, that the Oracle was entering a period of dormancy.

Nicholas assumed the office of Prince of Krondor while waiting for Prince Patrick to arrive with his father for Arutha's funeral. Once Patrick was of age, Nicholas would happily return to his post as admiral of the King's Fleet in the Bitter Sea and Sunset Isles as Patrick assumed the office of Prince of Krondor with his uncle, Prince Erland, staying on as his chief adviser.

The function of Calis's group was to travel to Novindus, under false colors as a mercenary band, to put in at the City of the Serpent River, where Calis had already established alliances with the various clans who ruled the city, then strike out to measure the advances of the Emerald Queen. What few in the Kingdom knew was that once this woman secured control of Novindus, it was a near certainty she would turn her attention to the two nations of Triagia, the Kingdom of the Isles and the Empire of Great Kesh.

From a casual appraisal of the situation, attacking the Empire's west coast seemed a more logical choice, for the Empire had fewer cities spread out over wider areas, with no easy way to mobilize forces to answer any assault. But because the royal family of the Kingdom knew of the existence of the Lifestone, they were certain that any assault in Triagia against the Kingdom meant the ultimate goal was Sethanon.

Twice now there had been assaults directed at Sethanon: the Great Uprising, and an abortive sortie by the Dark Brotherhood spurred on by the rumor that Murmandamus was alive and being held prisoner there. Lord James, when he was still serving in Arutha's court, Squire Locklear, and a young magician named Owen Belforte had helped the Kingdom defend the Lifestone a second time.

So why not a third attempt?

For these reasons, Lord James of Krondor, with the tacit permission of Prince Erland, acting as the Prince's regent, gave Calis permission to take his band of desperate men to Novindus again, to assess the threat to the Kingdom. As I recall those days, from my own agents, it was the best possible concession Calis could have expected, given the political chaos at that time. Few living today could understand what an absolute anchor Prince Arutha had been to the politics of the nation; under his rule, the Western Realm had almost become a sovereignty to itself, proving the benefit of a stable constituent without cost to the Kingdom.

Prince Patrick, on the other hand, was as impulsive as his father and grandfather at their worst, without the saving grace of tempered experience. Without a sure hand to

guide him, his leadership, should war come to the Western Realm, was very much in doubt. So Lord James, the former boy thief of Krondor Jimmy the Hand, determined to keep Prince Arutha's legacy intact, ordered Calis to take condemned men into a hopeless situation, to see if a small advantage might be gained by the Kingdom in preparing for another threat.

Miranda finally overtook me, literally across several worlds, and at last we met for the first time in the Pavilion of the Gods. We then exchanged information in my quarters in Stardock, the ones thought unused for decades. She had been working for the Keshians, as much as she worked for anyone, in much the same fashion Calis had been working for the Kingdom, attempting to assess the threat to the Lifestone by the Emerald Queen and her army. She had even gone so far as to have recruited Calis as an ally, though I suspected he never fully understood her motives—I married the woman and to this day I don't know if I have ever fully understood her motives.

⚜ *My mother was my father's equal in magic in most ways, but in all other matters they were partners. As a result, my mother often felt no need to share her intentions with anyone, including father. She even went so far as to employ agents of her own, outside of our organization. It was a complex relationship to say the least.*

This journey involved the most daring actions by Calis, as he discovered one reason for the Queen's rapid advance after years of slow conquest: the Saaur. I will tell of them shortly.

Calis traveled to Novindus to gauge the threat while Miranda and I set out to form our own conclusions as to the immediacy of the threat as well. A picture was forming that there were forces of magic involved that were far more dangerous than originally thought. The fall of the city of Kilbur, and later Lanada, revealed the Emerald Queen had resources that grew with her need.

By the time Calis had his company formed, he had been joined by Nakor, and two local mercenaries, Praji and Vaja, who were recruited for their familiarity with the local terrain.

In many ways, this particular voyage on Calis's part, while it resulted in some tragic losses, was less important for what it did, which was significant, than it was for the impact it had on two of those in the crew, Erik von Darkmoor and Rupert Avery.

Despite a full pardon, Erik decided to stay in Calis's service, becoming effectively third in command behind Calis and Bobby de Loungville. This would start him on a long path of service to the Kingdom, earning him rank that ended with him becoming one of the finest commanders and perhaps the greatest military logician in the history of the Kingdom of the Isles.

Roo decided to take his bonus in gold and invest it, as he had plans that included learning all he could about trading and someday becoming the richest man in Krondor, if not the Kingdom. He began his career at Barrett's Coffee House, the traditional meeting place for traders and underwriters and shippers, buyers, and sellers of cargo and commodities.

This became important for the simple reason that wars cost money. Monarchs can raise a certain amount of revenue through simple taxation, but any student of history will recognize that at a certain level, taxes cause more harm than good, for not only does it prevent growth for those in trade, and create hunger for those in farming, it encourages smuggling, tax cheating, and other activities that deprive the Crown of revenue.

So monarchs borrow. By the time the war with the Emerald Queen was over, Rupert Avery held more of the Crown's debt than any man in history. So how he acquired that wealth to lend to King Borric is a story of passing interest in its own right, as it's both instructive and a little entertaining.

In his vanity, Rupert Avery commissioned a biography to be written, entitled *Memoirs of a Master Merchant*, which is awash with self-aggrandizement, no small amount of

*Miranda Overtaking Pug
in the Pavilion of the Gods*

The Emerald Queen's Army Sacks Lanada

false heroics and taking credit for the achievements of others, but which also contains just enough facts and truth to make it worth reading if one is inclined. I have read the book and know enough of the facts to sift through it, and the irony here for me is that Roo Avery did enough remarkable things in his life this exercise in vanity was wholly unnecessary.

The final intelligence gathered from this journey proved valuable in several ways. We knew finally that the Kingdom was the Emerald Queen's destination. She would keep her army intact and use the massive shipbuilding facilities at Maharta to construct a fleet big enough to ferry her army across the ocean to the Straits of Darkness and into the Bitter Sea. As soon as Calis returned, Princes Erland, Nicholas, and Patrick began planning the defense of the Kingdom.

Nakor contributed immensely in his unique and seemingly mad fashion; the Emerald Queen's magic users had created a massive bridge of light that arched like a white and green rainbow over the Vedra River, and as it was growing, Calis's company was attempting to fire the shipyards. Their plan was to deny the Emerald Queen the use of the yards for building her invasion fleet, forcing her to spend a year or two rebuilding before launching her attack across the ocean.

When rain threatened to extinguish the fires, Nakor threw illusionary attacks against the Saaur and human magicians on that bridge and they responded by showering him with destructive bolts of energy that had the entire shipyard aflame within scant minutes. Nakor's "attack" was totally imagined, but it got the response they needed, and in the end Maharta's shipyards were destroyed.

Some of Calis's company got to shallow draft boats and managed to get out of the blockaded harbor, reaching the *Freeport Ranger*, while others made their escape overland to the City of the Serpent River where they rallied and took ships for home. But this voyage to Novindus by Calis and his band of "desperate men" gave us the warning without which we would surely have lost what was fated to be a difficult struggle in years to come.

Entry, the Fifteenth

I HAD MENTIONED THE SAAUR in the last section and neglected to expand on who they were and their role in what, because of their participation, has come to be known as the Serpent War, or the Second Riftwar, because of their use of rifts being part of this narrative. The Saaur are a race of lizardlike beings, though they are warm-blooded. They are massive by human standards, standing as tall as ten feet at times, nine feet being the average, and they ride horselike creatures that stand twenty hands at the shoulder, and they are master riders, among the finest heavy cavalry ever encountered on Midkemia.

I had cause to visit the home world of the Saaur, Shila, as Miranda, Macros, and I sought out the origin of an unexpected, strange twist to the story behind how the Saaur had come to Midkemia to serve the Emerald Queen.

Shila is a larger world than Midkemia, with fewer oceans. It has nine great oceans and a few smaller ones, some stunning mountain ranges, forests, swamps, tropical forests, and rain forests, but more than half the planet is rolling, grassy plains. The Saaur are nomadic people who were verging on what we would consider civilization. For a while the majority of their people were still nomads constantly riding toward the sunset, circling the world eventually; they had a rising population of cities and towns, and more Saaur were giving up their nomadic ways to pursue study and the arts. They had engineers, architects, builders, and magician-priests.

Despite the rise of cities, the majority of the world fell under the sway of the hordes, which were ruled over by the Sha-shahan, or High King. Each horde had a Shahan, ruler or King, who answered to the Sha-shahan. Everything under his rule was known as the

Empire of Grass. He was ruler of the Nine Oceans. His army was vast, even compared to the Tsurani, who could put a million men under arms at the Emperor's order.

Each horde numbered a million riders, ten hosts of ten *jatar,* a hundred centuries to a jatar, a century being one hundred riders. He commanded seven hordes, seven million riders.

He commanded a thousand cities, towns, and villages, and each horde had a million wives and children. Less than a dozen major cities still resided outside the empire. Thirty million subjects answered his every command, and those cities that were not under the banner of the Empire of Grass paid tribute—or were conquered.

To understand the dangers unleashed on Midkemia, one must first understand what happened to the Saaur and the world of Shila. It had been the dream of Jarwa, Sha-shahan of the Empire of Grass, to be the ruler who brought the last few great cities to heel, and so he personally led his hordes to the gates of Ahsart, the City of Priests. Of all cities on this world, this thousand-year-old village, then town, now a city had been home to mystics, magic users, and priests of all stripes. Gods worshipped nowhere else on Shila were said to watch over Ahsart. When confronted by the horde, a small group of mad priests did something unimaginably stupid—they opened a gate into the demon realm.

Thousands of demons, servants of the Demon King Maarg, flooded through, and a sixteen-year war began. At the end, the Pantathians arrived on Shila, offering what remained of the Saaur sanctuary on Midkemia, in exchange for service to the Emerald Queen. I am convinced that the Pantathians almost certainly played a part in the Saaur priests opening that demon gate though I have no firsthand proof.

After sixteen years of war, less than one-half of one horde remained, fighting a final battle against the demon host, in the ancient capital city of Cibul, while the Pantathians guided Jawar's son, Jatuk, to Midkemia. What soon became clear wasn't that we had to fear the

Emerald Queen and her army, alone, even with her Saaur auxiliaries, but the host of demons certain to follow after.

I mentioned that Rupert Avery and Erik von Darkmoor came from the town of Ravensburg. Given my usual mode of travel, there are many places I have literally flown over that I have never stopped to visit. I found myself in Darkmoor and decided to finally visit Ravensburg.

Darkmoor was the last major fortification created by Prince Richard before he founded his city in Krondor. Originally a simple tower keep, it took its name from a swampy moor to the southeast, the Dark Moor. It has long since been drained and cultivated and is now some of the better farmland in the area.

Erik's father was Otto, Count von Darkmoor, and there is a story about him and Erik's mother that might be told someday. As Erik is still alive, I'll wait until the opportunity presents itself to ask him if he would mind its inclusion in this narrative.

Ravensburg is the largest town on the highway from Darkmoor to Sethanon, and for years a major lumbering trade route from the Dimwood to the east. Lumber headed to Krondor and the Principality came down the highway from Eggly, through Tannerus, to Krondor.

Ravensburg also rests in a sprawling valley to the north of hills that don't properly belong to the Calastius Mountains to the west, or the Grey Range to the south, and are known simply as the Darkmoor Hills. Those hills and the valley are home to some of the finest vineyards in the world. There are like valleys in Kesh, the south end of Queg, and in Novindus, but it can be argued that the greatest wine on Midkemia comes from Ravensburg.

Three factors, two natural and one human, contributed to Ravensburg becoming the wine center of the Kingdom. The first is fine soil and abundant water. Several streams run off the Darkmoor Hills and form small lakes and large ponds throughout the region, as well as provide ample wells where needed. The second is a seemingly endless supply of

oak. A large portion of the Dimwood is ancient oak of several varieties, including live oak, red oak, pin oak, and white oak as well as a massive stand of cork oak near the southern edge. This provides staves for barrels, vats, and corks for bottles.

The third factor was Sebastian Sandovar. He was a Knight-Lieutenant in the army of Prince Richard whose father was a winemaker in Rodez, not far from the town of Dolth near the southwestern border of the Blackwood. While Richard moved on to Krondor, Sandovar was among those left to secure Darkmoor, and as part of his duties he conducted patrols all the way to the Dimwood. In later years, he was put in charge of creating the garrison that would become Sethanon. During his years serving the Crown, he got to know the area very well, and when he retired, rather than join the Prince in Krondor, he elected to return to Rodez, collect his father and brothers, and relocate to what is now Ravensburg. His captain, the first "von Darkmoor," gladly gave the town to his trusted aide and convinced the King to give him the rank of squire so he and his family would have the opportunity to develop the region without interference from late-arriving nobles who were certain to come once Prince Richard had expanded the region and trade opened up.

The Sandovar family took advantage of the opportunity. The father and two brothers brought cuttings of grapes and planted the first vineyard and traveled throughout the Kingdom and down into Kesh looking for better grapes over the years to come. It is said not one vine grows in Ravensburg that wasn't touched by the hands of a Sandovar. They also started the first lumbering operation in the Dimwood and built the first lumber mill near Sethanon, using the raw lumber business to subsidize their wine-making trade.

By the time of Sebastian Sandovar's death, Ravensburg was a thriving little town, Darkmoor was a major trading center, and the wine being made in the region was becoming legendary.

It's a beautiful area, with just enough rain coming over the mountains off the Bitter Sea, but not too much. It has just the right climate, and its wine is the best I've ever tasted.

Entry, the Sixteenth

I WRITE THIS YEARS AFTER MY LAST ENTRY, for many reasons that will become apparent as you read the following sections. I am not commenting on events that ended, for me, years ago, so I have the benefit of hindsight in detailing what occurred next in this journal of places and notable incidents.

During the few years following the fall of Maharta and the destruction of the shipyards there, preparations were made, but against exactly what forces we were unsure. Plans were drawn up, discarded, redrawn, and again put aside. Delicate overtures were made to Kesh and Queg, feeling them out on mutual defense. In the end some progress with Kesh was made, but Queg was indifferent, believing there was some nefarious motive behind the Kingdom's question.

In Krondor, Patrick was now Prince, named Heir to the Crown by his father, with his uncle Erland still acting as adviser. My son William was now Knight-Marshal of Krondor, which placed him in charge of all the Armies of the West, and Calis's Crimson Eagles had evolved from his mercenary unit to an elite company of the Prince's Own.

My daughter's husband, Duke James, was now completely installed as the power behind the throne, and it was among Patrick's wiser choices to keep it thus. Of all in the royal family whom I can claim a distant kinship by adoption, Patrick conDoin was the ruler I had the most difficult time with. In the end, I think I ultimately reached a more reasonable perspective on what my duties and obligations were.

But at this time I was closeted with Miranda, Nakor, and others on Sorcerer's Isle, or else using my powers to visit Novindus surreptitiously, keeping an eye on the Emerald

Queen. Miranda and I had spent over a year together on an unnamed little island not too far from the Sunsets, where we had become lovers, and discovered in each other we had at last met someone our equal in talent and intellect.

I still mourned the loss of my first wife, though time had distanced that loss a great deal after fifty years. My memory of her is idealized, I am certain, and had she lived, she'd be an elderly woman. Miranda is not forthcoming about her past so I can only speculate, but she may in fact be older than me.

Looking back, this was a transition for me, though I was scarcely aware of it, but at the end of it I emerged in some ways more like my earlier self, in other ways far different.

So we secretly plotted and did everything as if the Emerald Queen's spies were everywhere.

A few false reports were floated indicating concern for a possible assault in the East, but that was for the benefit of Keshian agents and spies from the Eastern Kingdoms. The royal family, I, and my allies—we knew the target was almost certainly Sethanon again, and the Lifestone.

By this time Rupert Avery had amassed a small fortune in trade, especially in the grain market, and was working on turning that into a large fortune.

Erik von Darkmoor was now a sergeant in the army, under the command of my son, William, who was now Knight-Marshal of Krondor. Calis was still captain of his special unit and had been joined by Captain Owen Greylock, former Swordmaster of Darkmoor. The business of the Principality was being overseen by Duke James, with Prince Erland still regent while Prince Patrick matured into his duties, and James's son, Arutha, Lord Vencar, was now serving as his father's first deputy. As much as it was possible for the Western Realm to be functioning well after Prince Arutha's death, it was.

Nakor came to visit me at Sorcerer's Isle and stayed awhile. I managed to get him to discuss his view on what had occurred down in Novindus, when Calis's company along

with Miranda and Nakor found themselves in the heart of the Pantathian warrens under the mountains. He spoke to me of things that I heard again from Miranda later, and in bits and pieces from Calis and others with whom I had the opportunity to speak over the following years.

Of all the events of my life that were entwined in the fate of Midkemia, the Tsurani invasion, the Great Uprising, and the first manifestation of demons here in Midkemia, the events surrounding the Serpent War, the Emerald Queen's War, or the Second Riftwar, no matter what it is called, these were the most confusing and complex to narrate. Part of that is due to the vast distances involved.

It sounds odd to say, given that I've visited other planets, traveled the Hall of Worlds, but what I have discovered is that the essential element for what must be done to meet these threats is communications. More on that when I have time. For now, let me return to the portion of this narrative concerning the Emerald Queen's invasion of the Kingdom.

There are so many events to recount, and much of the invasion history is well known, so perhaps I would best serve you, the reader of this journal, by speaking to some aspects of this war that were not widely known.

What was unknown to us until much later was an event that occurred on the Saaur home world of Shila. The last great Shaman of the Saaur, a venerable sage named Hanam, had contrived a means to seize control of a demon who had just come through the Pantathian rift into Midkemia.

In attempting to open the gate between Shila and Midkemia, the Demon King Maarg had sent one of his captains, Jakan, through the rift. Jakan then betrayed his master, seeking to find his own kingdom to rule.

To sum up, two demons were now loose in Midkemia with two entirely different purposes, one ignorant of the arrival of the other. The identities of both of them were unknown to us. What Nakor had determined at some point and relayed to me later was

that somehow the Emerald Queen had been dispossessed of her body and now the demon Jakan had replaced her, using powerful illusions to convince anyone who saw him that he was the Emerald Queen.

So while we knew the general size of the army that would eventually arrive, and while we planned for that eventuality, we really were still ignorant of the danger at the heart of this threat. I was still very ignorant on the nature of demons—which was true for all but a handful of magic users and priests—so it wasn't until much later I realized how disastrous it would be for a powerful demon to gain the Lifestone.

For although someone like the Emerald Queen might contrive to use the Lifestone in some fashion as a weapon, a demon would hungrily devour the massive life energies contained within, and if that occurred, the result would have been a Demon Lord of godlike powers.

I had concluded by then we must find Macros. Not having seen him for nearly fifty years made a search for him somewhat difficult, but I repeated that need many times over a period of months, mostly to the annoyance of Miranda.

We searched in earnest, our journey literally taking us through time and space, only to at last return to Midkemia and find him on the shores of Stardock Island. Dirty, wearing rags, unrecognizable, he had been thought a near mindless vagabond, a beggar who had somehow come to live in the community near the Academy. There I used my arts to reach out and sever a bond that was drawing him into godhood, as he sought to replace Sarig, the Lost God of Magic.

It was at that point I discovered Miranda was in fact Macros's daughter, and the Emerald Queen was her mother. I have since come to accept as a fact of life that Miranda tells me what she wants to tell me when she's ready.

⚜ *Years later my father and I discovered that, indeed, that had been the Pantathians who had created the dimension rift that opened the world of Shila to the demons and began the series of crises that were to plague Midkemia for decades.*

I also feel the need to say my father was entirely correct on my mother's nature. She was not what one might call forthcoming, but by the same measure, she wasn't particularly secretive. Secrets imply something to hide, and with my mother it was usually a case of her deciding you didn't need to know certain things, either as a matter of efficiency and expediency, because she had her own ideas on things and knew Father or I would disagree and just wanted to spare herself the argument, or because she had concluded whatever it was, it was nobody else's business. Unlike most traditional families, with the father as the recognized head of household, mine was blessed with a woman who had decided early on she needed nobody's permission to act as she pleased. My father was a powerful man, strong enough to cope with a very independent wife, and I grew up assuming that's how life was.

The tragic death of Prince Nicholas and Admiral Vykor overshadowed the brilliant plan to trap the Emerald Queen's fleet at the harbor mouth of Krondor and destroy nearly a third of her army before she came ashore.

This is roughly how I finally found out Miranda had come to be involved in this, as an agent for Great Kesh who deserted her responsibilities because she saw a threat that warranted a stronger response than merely protecting Kesh's interests. It's also when, in the single most arrogant moment of my life, I directly confronted the Emerald Queen, and discovered in harsh fashion she was in truth an extremely powerful demon who was expecting me and had prepared. I was almost killed and only by the strangest luck did I lie and recover.

Politics as much as warcraft and magic was in play in defeating the invading army, with a large portion of her army switching sides for political gain and wealth. A rogue unit tried

Quegan War Galleys Prepare to Attack the Emerald Queen's Fleet

A MAP accompanying the account of the Battle of Nightmare Ridge, from the report filed by Eric von Darkmoor, later Knight-Marshal of Rillanon.

to set itself up as an independent Kingdom based in Ylith, and that took time to solve. In the end, a heroic struggle in the Calastius Mountains along what is known as Nightmare Ridge ended the invaders' advance.

Like most wars, the reconstruction afterward was long and painful. Kesh attempted to take advantage of the chaos and for the first time attacked up into the southern Principality, to the very gates of Krondor, in an attempt to finally and for all wrest the Vale of Dreams from the Kingdom. I halted the conflict, but as a result I made my final break with the Kingdom, chastising Prince Patrick publicly before his own soldiers in Krondor and the invading Keshians. My relationship with the Kingdom is over. I suffered enough loss during this war that petty political loyalties didn't concern me.

⚜ *My father glosses over events again, neglecting to mention the terrible losses he, and the Kingdom, suffered in this war. He lost both his children, William, who died defending the city, and his daughter, Gamina, who died with her husband, Lord James, attempting to flee the city too late. It would be years before those wounds healed. The Kingdom lost Owen Greylock, Arutha—Lord Vencar—and its two finest admirals, Lord Vykor and Prince Nicholas.*

Section III

POST CHAOS WARS

AFTER MY FATHER'S BREAK WITH THE KINGDOM OF THE ISLES, declaring Stardock an independent entity, we entered a long period of apparent peace. I say apparent because many things happened that went unreported or were hidden.

Stardock was left alone by both the Kingdom and the Empire. This, I believe, is because the Kingdom was simply unable to press any claim in that region, given how badly mauled it was by the Emerald Queen and because of the resources needed to rebuild the West. Kesh pressed no claim, I judge, because the loss of a Kingdom claim on the island was already a benefit to them, and they thought better of trying to seize by force of arms an island populated by magicians, some of whom had already demonstrated their ability in warfare. So, despite the occasional attempt to infiltrate a spy into the population of the island, we were left to our own devices.

My mother and father married, quietly, on Sorcerer's Isle and as a result of the "dismantling" of the Lifestone Calis achieved at the end of the war with the Emerald Queen, my mother at a very advanced age was suddenly able to conceive. And I was born.

As was my younger brother, Caleb.

As children we took for granted things that would have been alien to the point of terrifying to people elsewhere on Midkemia. Our home was shared by students from other worlds, some whose appearance would inspire fear in strangers despite the students being among the most gentle, intelligent, and kind beings I've encountered.

With my father's refusal to consider himself subject to the Kingdom or Kesh, and with such a diverse population of students, it's easy to understand why my

brother and I grew to manhood devoid of any sense of national loyalty or prejudice. We took people as we found them.

I will comment no more on specifics, because my father did not, but suffice it to say despite the unique quality of my family, my parents were loving and kind.

Entry, the Seventeenth

I RETURN TO THIS AFTER SUCH A LONG ABSENCE I had to reread what I've written so far. As is often the case, issues become pressing, and this sort of project, organizing all the maps and charts into something coherent with a narrative to connect the elements, becomes a leisure-time activity when leisure time doesn't exist.

So many events have occurred that to detail them would prove a lifetime undertaking. I now have two grown sons. Suffice it to say that there are many histories and personal journals regarding what has come to be known as the Serpent War. The near total destruction of the Prince's City and the invasion of the Army of the Serpent Queen and the effects of that struggle are also widely known. A common misconception is that the struggle ended with the Battle of Nightmare Ridge, but that is not the case. The struggle continued long after the battle.

Over the course of those years, quite a number of small, hidden struggles erupted, thwarting our enemies' plans, disrupting lines of communication, destroying caches of supplies and resources, often leaving us with little or no sense of a bigger plan. All we knew was we were causing harm to our enemies.

I have gotten ahead of myself. After the end of the Serpent War, I determined that two things had to change. The first was severing all ties with any nation. That I did in somewhat dramatic fashion with Prince Patrick of Krondor. Which brings me to the second thing that had to change: Stardock had become nearly useless to my larger needs; it had become another Assembly of Magicians. It was evolving into a Guild of Magic. Its magicians had even begun to broker commissions for providing magic aid to nobles in need of special services.

More, they had sought to take control over some small guilds utilizing magic in their craft, the Mudcrafters and the Salvagers. The Mudcrafters had one relatively trivial spell of magic, how to turn rock into mud and reverse the spell. For building, it was an efficient way to make walls, tide jetties, and foundations for buildings. It was becoming a highly profitable trade, and the secret of that spell is jealously guarded by the guild, who have no wish to come under the authority of Stardock.

The Salvagers likewise have two minor magic abilities, to dive deep underwater for very long periods of time without need to breathe, and to raise wreckage, bringing it to the surface. They also have no desire to come under Stardock's sway.

So, besides bringing the finest of students to Sorcerer's Isle, I have also created an organization called the Conclave of Shadows.

It is a group dedicated to finding the root source of all the ills that have plagued Midkemia since the Riftwar and putting an end to them for well and good. Miranda and I are apparently destined to be very long lived, so we look upon the Conclave as a longtime commitment. Our longevity is clearly a result of our abilities, just as there are prices paid for using what we call dark magic, and from recent experience, it seems the first price paid for the dark arts is sanity.

Which brings me to a particular master of the dark arts, whom I first heard of by the name Sidi, but later encountered calling himself Leso Varen. Our paths crossed on several occasions, though at certain times we both were ignorant of that fact.

One story that might illustrate best how our conflicts with the agents of darkness moved into small arenas of conflict, which in turn had large-scale consequences, concerns a young man—one might have called him a primitive—from a small tribe of mountain people in the Eastern Kingdoms. His name, in his own tongue, translated to Talon of the Silver Hawk.

⚜ *I presume to interrupt my father at this point as this was the first instance where my part was more central and critical than my father's. Even as I write that, it feels odd, but my father came late to Talon's involvement in the business of the Conclave.*

The magician my father named, Leso Varen, had insinuated himself in the household of a very ambitious Duke, Kaspar of Olasko. Olasko had at one time been a provincial outpost of the Kingdom of Roldem, but broke away centuries before. The map of the Eastern Kingdoms shows a crowded neighborhood of nations. Each has its own history, tradition, and culture, offering a great variety to the traveler, as well as no small amount of dangers, as the first best pastime of the Eastern Kingdoms seems to be making war on one another.

Only the specter of enemies behind their backs while they wage war against a determined defender keeps any of them from trying to expand westward, across the Grand Salnamar River. The Duke of Ran has had enough conflict with adventurers coming across that wide river from Maladon, Dungaram, Tuskalon, the High Fastness, and other points up to Farinda. As a result, Ran is considered to have the most battle-ready army in the Eastern Realm.

It was in this context that Kaspar, Duke of Olasko, sought to expand his influence through strength of arms and wished to war against the Duchy of Franinda, on the other side of the mountain range known as the High Fastness. Only one route presented itself without violating the borders of nations with which he did not currently wish to go to war, a series of interconnecting valleys running through the mountains, south of the High Reaches. The difficulty was these lands were occupied by a peaceful tribe of hunters and farmers known as the Orosini.

Kaspar's solution to this tactical problem was direct and simple: obliterate the Orosini. He hired a mercenary army, under the command of a black heart named Raven who killed the majority of those harmless, gentle people, keeping a few to sell as slaves.

By then the Conclave had established listening posts throughout the world, in places we judged critical. Inns and trading posts in key locations proved valuable sources of information. One such was a trading post, a fortified inn, by name Kendrick's Steading. Originally it had

been an attempt at farming, but Kendrick quickly came to realize he'd picked a terrible place for a farm.

His neighbors included a high number of thieves, marauders, and generally hostile people, and he had put himself squarely on an efficient route through the mountains for the northernmost nations, some tribal areas, and routes to the south and west.

In short, he'd try to claim the hub of a smuggler's highway.

Kendrick was barely able to keep his buildings from being burned and his family and servants from being slaughtered when one of Father's agents found this Steading. With some help from the Conclave, the Steading inn quickly became the only safe roadhouse between the Land of the Orodon—distant kin to the Orosini—and the Duchy of Farinda, in a tiny little nation known as Latagore. The Prestmauk of Latagore, their ruler, happily granted a patent to Kendrick in exchange for a healthy bribe, giving the Conclave's listening post a patina of legitimacy. That didn't keep Kendrick's neighbors from continually trying to raid his little fortress, but it provided Kendrick the license to retaliate or occasionally preemptively attack without fearing any interference from local government. Within a year, Kendrick had been successfully recruited into the Conclave and was a valuable source of intelligence.

The Conclave literally has hundreds of places like Kendrick's scattered around Midkemia. Men like to boast to pretty girls, talk success with friends—more with rivals—and generally let slip information best not revealed, more so with ample drink to goad them.

Two agents of the Conclave, Pasko and Robert de Lyes—our most powerful magician in that region—had been following Kaspar's carnage closely, in a wagon posing as traders

THE EASTERN KINGDOMS, copied from a map in the Royal Library at Rillanon. While the borders of these nations are often in flux, this map fairly accurately accounts for their present dispositions.

Eastern Kingdoms

The High Fastness of the Eastern Kingdoms

heading to Kendrick's, when they found one left alive among the slaughtered Orosini, a boy named Talon of the Silver Hawk.

Nursing him back to health, Robert decided Talon was a young man of potential, and faced with two choices, abandoning him without resources in the wilderness or bringing him into the Conclave, he felt he had no choice.

I answered Robert's call and after spending some time with the youth, came to the same conclusion. He had potential. So I told Robert and Pasko to begin his training. Kendrick had been a mercenary soldier in his youth and he taught Talon as much swordcraft as he could, recognizing Talon had the potential to be a great swordsman. My brother Caleb spent time at Kendrick's as well and helped Talon improve his hunting skills, which had been of high quality from his training by his father, and judged him an exceptional archer.

Talon of the Silver Hawk came to Sorcerer's Isle and proved to be a willing student. Part of this, I believe, was his having few other choices, given the destruction of his people at the hands of Kaspar of Olasko, and part of it came from a natural curiosity of nature and desire to learn. He proved his worth in a completely unexpected way one day when our enemies sent three death-dancers to kill my son Magnus.

Death-dancers are summoned beings, akin in a fashion to demons, but specifically designed to kill powerful magic users. They are very fast, hard to see, and lethal.

Expecting a magic user, they were completely unprepared for a gifted swordsman. Talon would have died save my son and I, among others, instantly recognized the magic threat and arrived in time to dispatch the dancers, but his speed and instinctive use of a sword to protect himself kept him alive long enough to survive.

We honed Tal into a weapon for the Conclave after that. He studied languages, court manners, and all that was needed to create the illusion of the perfect minor noble of the Kingdom. Arranging a false patent of nobility was easy enough, and Talon of the Silver

Hawk became Squire Talwin Hawkins, a very minor noble of the Kingdom from a tiny estate near the city of Tyr-Sog in the Western Realm, and we turned him loose in the city of Roldem. He was victorious in the celebration known as Masters' Court, a competition designed to select the finest swordsman in the world, held once every five years.

The story of his victories, and the unexpected deaths of two of his opponents, have been written about in colorful fashion in other places. Let us say that the best result of all was his taking service with Kaspar of Olasko, his most hated enemy, whom he wished to overthrow.

Tal's story is long and complex, but in the end he helped us discover important information that proved vital in days to come. We had labored under the burden of not knowing the identity of the true master behind the destruction visited upon us over the years, and now we had a name, Leso Varen. He managed to escape through the use of necromancy when Olasko was finally defeated, but we had him marked and set out to track him down with every resource at the Conclave's disposal.

Olasko was annexed to the Principality of Aranor, and both nations were declared protectorates of Roldem. Duke Kaspar of Olasko was spared death, as despite his well-earned reputation for ruthlessness and ambition, he had fallen under the sway of a monster, and it was unclear if he deserved to forfeit his life. So he was banished to the wild lands of Novindus.

⚜ *This proved provident, for Kaspar later found his way to the Conclave with an artifact from another dimensional realm and a warning of an even more dire threat than what we had experienced. There is a great deal that took place during this period my father refused to comment on.*

Talwin Hawkins Fights at the Masters' Court

The Eastern Kingdoms are misnamed, for there are no true Kings in residence. Still, the name has endured. Originally these were regions that were explored first by either Rillanon or Roldem, with enclaves and outposts established to stake claim and make way for colonization or exploitation of resources.

Over centuries, the borders have shifted regularly, ruling families have risen and fallen, and in the end few powers have endured to pose a serious threat to the larger political entities of the region. The Southern "Kingdoms" are more problematic for the Kingdom than the Northern nations.

Most powerful in the region was Olasko. First, it was a relatively successful colony of Roldem's for nearly a century until a civil war on the home island coupled with a revolt in Olasko created the independent duchy. At various times the ruler has styled himself "Grand Duke," "Prince," or most commonly just "Duke of Olasko."

Next in influence is the twin Duchy of Maladon and Semrick, two duchies that merged when the two ruling families united in marriage and produced a single offspring who held claim to both nations. After nearly a hundred years, the single nation with two names endures. Their political ties to the Kingdom keep them safe against their more powerful neighbors.

Roskalon, Miskalon, and Salmeter are the three most successful trading nations in the East, with three huge trading ports, Prandur's Gate, Watcher's Point, and Micel's Station, with ambitious eyes toward trade and a high tolerance for contraband. All three have been likened to Durbin in the Bitter Sea, but the comparison is unfair. All three cities are free of pirates, though they are known to be safe harbors for the Ceresian pirates who raid constantly along both Kingdom and Keshian coastlines. The Ceresians sail from various islands scattered along the coast from the Duchy of Olasko up to the Lands of the Orodon, and no man not a Ceresian knows exactly where. Numerous attempts have been made to locate their bases, always ending in failure, but the more cynical among the traders in the

region avow that should the Ceresians ever be hunted down and stamped out, the three cities of the southern nations would be penniless within a year.

 Far Lorem, the Principality of Aranor, County Conar, and the High Reaches are all unique lands with languages and customs odd and quaint by Kingdom standards. Still, each possesses traditions and heritage worth study. Someday I hope to have the time to give serious attention to these lands, and the people living within.

A MAP SHOWING THE COMMON TRADING ROUTES in the Sea of Kingdoms and along the coasts below the Peaks of the Quor and up through the Eastern Kingdoms.

Entry, the Eighteenth

SOME YEARS AGAIN HAVE PASSED SINCE MY LAST ENTRY. Kaspar of Olasko returned from his exile carrying word of grave threats that caused the Conclave to turn its undivided attention to another source of danger. He carried with him a device, a creation of evil called the Talnoy, a thing of artifice that carried within it a trapped soul.

I left it with the Assembly of Magicians on Kelewan, asking them to investigate it.

I have set down in another volume details of the occurrences of what has come to be called in the Conclave, the Dark War. It is called that because of the unusually brutal and unrelenting struggle, with a price unimaginable to any sane being, and because it is as well kept a secret as can be imagined for what is, in effect, the Third Riftwar. That is because the struggle took place on another world, and more than that I will not disclose here.

⚜ *My father's reticence is understandable as he was the author of the destruction of an entire world, Kelewan, his home for a while during the Riftwar, and while he labored without cease to save as many people as he could from that destruction, and to that end he succeeded, a full three out of five Tsurani, Thuril, and other peoples of that world perished in a desperate bid to thwart the actions of our enemies.*

The only advantage realized in this madness was that the true enemy behind all this misery over all these years was revealed, the entity we called the Dread. There had been a school of thought that perhaps it was the God of Evil, the Nameless as he is known, who had been its architect, because it was clear that Leso Varen had been a servant of that Dark

One, but later intelligence proved he was but another dupe of those serving the Dread.

One event in all this that bears notice was the death of Nakor. He remained on the Dasati home world as my father engineered the destruction of the rift traveling from there to the Tsurani home world, Kelewan. That loss was felt by all of us, but most heavily by my father. His failure to mention Nakor's loss in the previous entry, and only in passing later, hints at the deep sense of loss, confusion, and anger my father felt.

And the near crippling guilt over the destruction of an entire world. As I write this, I look back on events with the perspective of time, recognizing that I have often underestimated my father's burden. Such are the conceits of sons toward their fathers, I fear.

I have at times mentioned the Pavilion of the Gods. It is as best I can judge a metaphorical place, not existing objectively in our world. Yet each time I have visited it, there was a sense of permanency and a reality to it, albeit subjective. In any event, some time back I described in detail to a student here on the island what I remember of its layout, and as a gift to me, he created the map I now include here. Were I more rigorous in my organization of this material I would probably do well to place this map where I narrate Tomas's and my first visit, or perhaps when I first encountered Miranda, but I lack the motivation to unbind what is bound so far.

If that reflects ill upon me, so be it.

⚜ *My father was enduring a dark existence in many ways since returning from the conflict on the Dasati world and with the destruction of Kelewan. While he somehow managed to accept the necessity of all those lives lost, the loss of Nakor haunted him. There was a time when my father would have gleefully unbound this journal, selected an appropriate page behind which to insert this map, then sewn the entire volume back as it was. Such was his mood at this time that even so trivial a task was daunting.*

Floor plan of the Pavilion of the Gods, showing hexagonal tiles arranged around the room. Labels include:

- *Onan-Ka Ruby (Crimson)*
- *Ruthia Gold (Gold)*
- *Banath Granite (Dark Gray)*
- *Lims-Kragma Onyx (Black)*
- *Killian Malachite (Forest Green)*
- *Guis-wa Silver (Silver)*
- *Ka-hooli Granite (Light Gray)*
- *Prandur Rose Quartz (Rose)*
- *Silban Granite (Brown)*
- *Astalon Lapis Lazuli (Sky Blue)*
- *La-timsa Quartz (White)*
- *Dala Quartz (Yellow)*
- *Crystal Windows*
- *Conspicuously Unused Space*
- *Opening*

THIS FLOOR PLAN depicts the arrangement of the statues of the gods in the Pavilion of the Gods, high in the peaks of the Ratn'gary Mountains of Novindus.

We were all thankful that it was only in such little things Father showed his despair. In matters of consequence he was attentive and focused. We waited and hoped he would eventually get over Nakor's loss and return to better spirits. I fear we were almost naive in that hope.

I was summoned to the chamber below the city of Sethanon by the Oracle of Aal. As I arrived, so did a major demon, which required no little effort to destroy. The Oracle had summoned me at that particular moment for two reasons: to save her from that demon, but to also warn me we were heading toward what she deemed a Nexus, a coming together in time and space of many probabilities, and that the future after was dark until certain issues within that Nexus were resolved.

Demons played a large role in all the conflicts over the years, and as we recovered from the events in what is now called the Dark War, a Demon Master sought us out. Kaspar of Olasko had made his home in Novindus after ridding us of the risks of Leso Varen and his allies during the Dark War, and a demon summoner, by name Amirantha, came to him in the city of Maharta.

Kaspar quickly deduced this is someone I should meet, for several reasons, but the two main reasons were he was the youngest brother of the magician Sidi, or Leso Varen, and he brought a warning regarding demons.

An additional expert in demons, at least in destroying them, came to join us eventually as well, a Knight-Adamant of the Order of the Shield, servants of the goddess Dala.

The other event of note was the returning to Midkemia of an ancient race of elves, self-styled Taredhel, or "Star Elves," an impressive group by any measure. Taller than their other kin by a half-head's height or more, they were of a nature unlike their brethren on Midkemia. These were elves who had fled Midkemia via rifts during the first Chaos War, finding a home where they could recover and build their own nation without Valheru control.

They built cities and they claimed planets and grew to multitudes undreamed of by other elves, numbering in the millions. Seven worlds around seven stars they colonized, then they encountered the demon host.

As with the Saaur on Shila, only this time across worlds through what they called "portals," or rifts, the demons came in unrelenting waves. The Lord Regent and his council,

Pug Helps the Oracle of Aal

the Regent's Meet, sought refuge and found their way back to their home world, Midkemia, with demons in pursuit.

We set out to learn as much as we could about this coming demon horde, for it was now clear to me this was our next attack from our true enemy, the Dread.

In discussing the following events, a few amendments to earlier entries are in order. The Taredhel built their new home in the very valley in which the Tsurani erected their rift gate so many years ago. I am something of an expert on the topic of rifts, so I can say with a fair degree of certainty that this valley is now the most likely place for any rift not specifically targeted at another location on the planet to terminate. It is the nature of rift magic that scissions are formed, lines or cracks if you will, in the very fabric of time and space that draw magic through, as water runs through a crack in stone, to that terminus.

The elf city is, by all reports, worthy of a visit.

I did have the opportunity to visit the city, called "E'bar" in the ancient elven language, meaning "Home." It was a place of astonishing beauty, yet it was an aloof beauty if I may affect that judgment. There was a cold precision about it that always lingered in any appreciation of the otherwise stunning achievement.

Taredhel geomancers, magic workers of stone, possess an art so far beyond what human Mudcrafters are capable of, it begs comparison. While the human may haul rocks out of the earth, transport them to a site, pile them into forms, and transform them to mud, then re-form them as rocks, the geomancer seems to call rocks up out of the soil to do his bidding, as if wishing them into the shape he desires, and in whatever hue he chooses. So E'bar is a place of soaring towers of stone, high arching bridges between them, massive defensive walls, and stately buildings and homes, all constructed by magic within months, where a human monarch would spend decades achieving a similar feat, and with far less spectacular results.

Yet there is an absence of grace, for lack of a better way to put it. There is a marvelous range of colors at every hand, as pastel reds and oranges trim walkways of gold flecked with white stone, and ramparts of rust and vermillion set atop walls the color of pale lemons. In all this, there is a lack of emotion; it is as if the precision of everything robs it of art.

It is a tragedy that nothing remains of E'bar, for despite my perception of artistic flaws, it was a feat of engineering and design unmatched by any other city I have encountered on this or any other world.

In the course of seeking information as to the rising role of demons in the conflict between the Conclave and our opponents, we sought out a legendary volume on demons, reputed to be contained within the royal library in Queg.

I have only mentioned Queg in passing so far, so allow me to touch upon that strange nation for a moment. Queg was a unique colony of the Empire of Great Kesh.

As mentioned before, at the heart of the Empire stand the original Keshians, those who refer to themselves as "Truebloods," and no matter what rank is achieved by anyone else, they are considered inferior.

There was one group that stood in the shadow of the Truebloods, yet claimed kinship, in times ages ago, far enough back that history and myth blend. They were called the Quegans, and in the vernacular of the time, they were from the wrong side of the lake. The tribes that hunted along the shores of the Overn Deep were of one bloodline, but those on the north shore grew to dominance. Language and history made it impossible for those who rose up to found Kesh to deny their relationship to those from the south shore, but they made every attempt to do so.

After centuries of bitter conflict, when the Bitter Sea was reached by the first Keshian explorers and the first colonists were sent north, the last tribe of Quegans was given title to the island, which the tribe immediately named Queg, and migrated there to the last

Sandreena Receives Her Commission

child. Affecting the attitude of Truebloods, the Quegans declared that they were the only aristocracy and any other colonist was a peasant. Thus the two-caste system in Queg was introduced that is still in force today. So even the most enterprising, successful commoner must have a noble patron, else they would never be allowed to succeed, and again thus, as strange and convoluted a system of patronage and privilege known on Midkemia exists on the Island Kingdom of Queg.

The Quegans' claim of empire is amusing except that occasionally they would seek to claim dominion over the Free Cities, which on several occasions were forced to repulse their military. Fortunately for those who share the Bitter Sea with Queg, while their navy is prodigious, the nation's army is barely adequate to keep its own population under control. The Quegans' three attempts to colonize what is now the coast of the Principality before the Kingdom reached the Bitter Sea all ended in successful rebellion or the complete collapse of the colony.

Today, Queg is a closed-off nation, requiring strict protocols for a visit. One must arrange travel to Queg through a sponsor, either one of the nobility or a highly placed merchant. Arranging such requires application through the Quegan ambassador's residence in Durbin, Krondor, or Port Natal. Failure to secure proper visas ensures a quick arrest and trial as a spy. Only those with patronage are allowed to defend themselves at trial; therefore, the simple act of being arrested guarantees a conviction. The sentence is always life at hard labor, usually in a Quegan war galley, unless suitable ransom can be arranged. Sailors wrecked at sea in sight of Queg have been said to drown themselves rather than swim to shore, knowing that even a shipwrecked man without a patron's visa would be convicted of being a spy.

The one exception is foreign sailors on leave in the Sailors' Quarantine of Queg City, Ponaqua, Palenque, or Conquala. Inns, taverns, and brothels abound in those four ports, as well as confidence tricksters, slavers, card cheats, pickpockets, and muggers. As the

A trading map of the Bitter Sea. Origin unknown, but it was buried in my father's papers.
—Magnus of Sorcerer's Isle

only two punishments for committing a crime in the Sailors' Quarantine are life in the galleys or death by crucifixion, the profit margins for crime must be very high, Quegan criminals are very stupid, or, as some cynics have opined, the Quegan constabulary are easily bribed.

Sailors in the Quarantine are advised to be wary of those offering to buy drinks, for if a stranger drinks ale and finds a Quegan coin at the bottom of the cup, he is said to have accepted the King's gold and therefore the King's service, and he is bound to the galleys. The only mitigation is that "voluntary service" is only for ten years, not for life.

Such is the insularity of Queg that to investigate their library, searching for the tome on demons we believed would be there, that I, my son Magnus, and the Warlock Amirantha arrived in Queg disguised as scholars, me being from Rillanon, my son from Yabon, and Amirantha from the distant land of Muboya, all under the aegis of one Lord James Jamison, or as I knew him, Jim Dasher.

Jim is the several great grandson of the first James of Krondor, Jimmy the Hand, and more like that man than any I have ever known. If anything, Jim may be a little more deliberate and less impulsive, but in every other way that counts, he is his equal. Jim's grandfather was Lord Jamison, Duke of Rillanon, twin to the late Dashel of Krondor, sons of Arutha, Lord Vencar, grandson of Jimmy the Hand.

Jim is an interesting and complex man who serves both the Kingdom and the Conclave, and I am not certain if he serves the Conclave for the sake of the Kingdom, or serves the Kingdom for the sake of the Conclave, or if it really matters. Never has he officially claimed it, but I believe him to be the head of the Kingdom's network of agents throughout Triagia, many of whom also serve both the King and Conclave.

While I have my concerns over any ties between the Conclave and any given nation, so dire are the threats to this world that I am willing to put aside my apprehensions over such and take a more pragmatic view of things: Jim makes things work.

Magnus and I could possibly have entered Queg's Royal Library by magic, unless that part of the palace was warded, and even then we might have foiled detection, but we really had little idea what we were looking for, just the title of one ancient book on demons.

So we needed to ensure Amirantha was with us, and to do that, Jim Dasher's patent as a noble of the Kingdom, and I'm certain the work of agents in Queg, got us permission to research the library.

Queg is a far more powerful nation than it has any right to be, but it is situated at the heart of the Bitter Sea, hence all shipping is subject to its predations. Taking advantage of that location, Queg has built what amounts to three fleets. It has a strong merchant fleet that sails as far away as the Keshian coast on the so-called Endless Sea, to as far away as Farafra. The navy consists of heavy war galleys, biremes and triremes, cumbersome and slow, but holding a huge advantage in the difficult winds of the Bitter Sea and deadly when within striking range. The nation also has a large number of small ships it provides marque to, privateers who are supposedly keeping pirates out of Durbin in check, but in reality who are competing with the pirates in Durbin to see which Kingdom, Free Cities, or ships of the other nation they can capture and loot first.

What makes Queg even more difficult a neighbor is its riches. A spine of mountains runs from the north tip of the island to the south. Huge copper and iron deposits are found in those mountains, as well as tin, gold, and gemstones, providing Queg with a huge supply of trade materials and resources for arms and armor. The foothills were naturally blessed with orchards of fruit trees and grapes quickly tended into vineyards, producing a reasonable quality wine. Rolling fields between Copper Deep and Ardentrum, and along the whole of the eastern shore, provided grain enough to export. The mountains were heavily forested and water was abundant. In short, Queg could exist entirely self-contained, with no trade with the outside world. That provided them with a huge advantage in any conflict with their neighbors.

QUEG AS DRAWN FROM MEMORY by an agent from the Prince of Krondor's intelligence corps. It lacks detail, as the Quegans are especially suspicious of strangers and watch them closely. This is a copy of the original.

Queg also boasted one other advantage. A breed of eagles, massive with spans three times normal, lived only on those peaks. Tomas once told me he believed them to be descendants of those birds that served the Valheru Ashen-Shugar. The Quegans have bred, for lack of a better word, riders for those birds. Men who are the size of small boys, and who can sit a harness atop the shoulders of those birds. The range of those ridden birds is limited, as is the load they can carry, but the advantage of seeing the enemy from on high is not to be discounted. Nor is the threat of even a small jar of Quegan Fire dropped from above onto the deck of a menacing ship.

As I mentioned regarding the fall of Armengar, Quegan Fire is a naphtha-based compound that will not be put out with water. Even a small amount dropped on the deck of a ship can disable it, and the eagle riders are capable of carrying two such jars at a time.

I arrived with my companions and we managed to infiltrate the library at Queg. Jim's portrayal of a bored court noble required to shepherd three scholars around was played to perfection. In the end we found the tome, the improbably titled *Libri Demonicus Ampuls Tantus,* or *Really Big Demon Book.* In the ancient Quegan tongue, it most likely was intended to mean *Physically Big and Really Important Book on the Subject of Demons.*

It took some searching of the Imperial Library in Queg, but Amirantha found the volume, and without much difficulty Jim stole it. We secreted it aboard our luggage and returned to the ship after our visit was over. Once far enough away from the city of Queg not to concern ourselves with Queg's magic wards being alerted to our departure, I carried my companions to Sorcerer's Isle and we began to study the book.

Much of what was contained within that tome was colorful nonsense, but according to Amirantha, a large portion of it was some of the finest scholarship on demons and the nature of their realm, the Fifth Circle, as could be found in the world.

Pug, Amirantha, and Magnus Study
the *Libri Demonicus Amplus Tantus*

That would prove beneficial, for shortly after defeating an attempt to bring a demon legion through a gate down in Kesh, knowledge of demons and their lore would prove incredibly vital.

We met with a Star Elf, Gulamendis, a Demon Master, and his brother Laromendis, a Conjurer, and learned some history of the Taredhel. We also discovered that a host of demons fought across a hundred planets for centuries.

There was a war among demons that was somehow involving us.

Entry, the Nineteenth

AFTER COMPARING WHAT THE TAREDHEL DEMON MASTER and the human Warlock knew of demon lore, my father determined he must return to the Saaur home world of Shila and find the ancient library in the city of Ahsart. My father, I, and a pair of younger magicians named Simon and Randolph went there and explored what was left. In so doing we discovered the Demon King Maarg had broken through to Shila, stranded himself, and died of starvation on a lifeless world.

That left us with the question of who was behind the demon attacks that were reputed to be led by Maarg. Father then deduced that we had all been victims of a hoax of massive proportion. He expressed certainty that all this had been one long conflict going back to the time of his captivity, and that even the Midkemian gods might be pawns in a larger game than we could imagine.

When we attempted to return to Midkemia, we discovered we were blocked. My father was considered to hold the supreme knowledge of rift magic and he was at a loss to know how this had been perpetrated and by whom. Rather than attempt to break the spell that locked

us out of this rift, Father elected to have us help him fashion a new rift, confident of his own skills in reaching home. It took approximately an hour to finish the spell and we stepped through into chaos.

My mother, Sandreena the Knight-Adamant of the Order of the Shield, Father-Bishop Creegan of that order, Amirantha, and others had traveled to the Peaks of the Quor, home to a strange and alien race, and discovered two bitter facts: that something was so powerful it had wrested control of demons out of the hands of their usual masters; and that the entire encounter there had been a ruse, designed to lure Miranda and her companions away from Sorcerer's Isle, just as Father and I had been lured to Shila, so a monstrous attack could be launched on Sorcerer's Isle.

We returned to a battle that was close to a stalemate, and with the addition of Father's and my magic, we quickly ended it. In the smoking ruin of our home, a demon feigning death leaped upon my mother, killing her before anyone could intervene. My brother and his wife also were among the dead.

It was as tragic a day as I am capable of imagining.

Entry, the Twentieth

ENOUGH TIME HAS PASSED *I feel able to further comment on this work, though as you might imagine at this point in my life, it is more of an amiable pastime than a pressing concern. Still, the value of a constructive narrative about the world in which we labor has its own value; else I would have abandoned this as my father did. I asked him and he waved* off my question regarding this work.

The only reason this work is intact is that the majority of works referenced here still reside in Macros's tower in the Black Castle, or in my father's sanctuary in Stardock. How much more I contribute to it, or if my father will ever return to it, remains to be seen.

I do notice that as I sort through my father's notes and attempt to further organize both that material he brought together and additional material I have discovered, old feelings, many of those unwelcome, return unbidden. With that in mind, I make no promises to continue this project with the rigor I applied years previous, but simply to promise I will try.

Entry, the Twenty-First

AFTER SEVERAL MONTHS, I find myself nagged a bit about certain aspects of this journal that are probably lacking to you, the reader. It's odd, isn't it? I find myself confronting dire threats, yet I worry that you might read this someday and be a little confused.

In the last entry I mentioned the Peaks of the Quor and the odd beings who live there. Some years ago, an expedition was dispatched to that region due to rumors of odd occurrences that were likely to be linked to the enemies we faced. Kaspar of Olasko led that group, joined by Jim Dasher in his guise as common thief, and my brother's three foster sons, Jommy, Tad, and Zane. They found two groups living in the Peaks, a race of elves we'd never encountered before, the Sun Elves, or Anoredhel, who were tasked with guarding a race known as the Quor. They were a very alien, green-skinned race who guarded another, even stranger race—if indeed they are truly sentient beings—the Sven-ga'ri. These are creatures, things, whatever they may be, who seem to communicate with emotions that border on the blissful, filling any human who comes near with a sense of beauty so powerful it is almost overwhelming.

The Anoredhel were dying, isolated for years and troubled by a type of Dread never encountered before. Word was carried to my mother and then to Tomas in Elvandar and aid was sent. A company of elves, formerly living in the Edder Forest, traveled to the Peaks to bolster the dwindling community there. As I write this, the mystery of the Sven-ga'ri and the Quor are another matter to which I may return someday.

Entry, the Twenty-Second

I RETURN TO THIS TO AMEND EARLIER PASSAGES, *as the political reality of all the region from the Far Coast to the Eastern Kingdoms has shifted dramatically. As a result, much of what has already been touched upon is no longer accurate.*

Let me begin by speaking of a region of Triagia known as the Keshian Confederacy. I'm including a map from my father's archives. This map came from a map-seller in the city of Great Kesh, and was reputed to be accurate at the time my father purchased it.

If this map had been drawn yesterday, the first thing one must realize is that everything south of the Girdle of Kesh is fluid. Boundaries are nonexistent except for a few naturally occurring ones.

Our first inkling that difficulties were heading our way came with reports of unusual shipping activity in the southern half of the Empire. I discovered Jim Dasher undertook a journey of exploration and found that there were Pantathians involved. Our belief we had somehow destroyed their nests proved false.

Three men rose in influence and power in three nations, Lord John Worthington in Roldem, Sir William Alcorn in the Kingdom of Isles, and Prince Harfum of Great Kesh. What became apparent later is all of them were the same man, or rather the same man duplicated. False beings, like the false Murmandamus and other Pantathian servants sent to beguile and confound, they had a mission, which was to plunge three nations into needless war, to distract us from their true purpose.

The truth is three men were in position to rise quickly in three royal courts, the genius being they were minor nobles whose influence was effected by an ingenious plot years in the fashioning. It wasn't merely that these three men had the ear of people in critical positions, Kings, Princes, Dukes, Chancellors, and other royal advisers, but also that they were given the power to appoint people to positions that appeared to be of minor importance, but in the end turned out to be critical: masters of ports and customs, those responsible for directing freight to military outposts, those assigned the duty of resupplying and reinforcing garrisons. Slowly efforts were brought to bear in the Confederacy to begin relocating people. To understand the genius in this plot, you must know a little about those lands.

People speak of "the nations of the Keshian Confederacy." This is a misnomer, for these are not nations. In many cases they are not even coherent cultures and tribes, but rather loose associations of people brought together by circumstances when they deem such alliances mutually beneficial, just as warring between them occurs when they deem that beneficial.

The geography of that region is not hospitable for the most part. The one stable region south of the mountains known as the Belt is the land of the Isalani, Nakor's home. To the north those lands abut the mountains of the Girdle, and to the south, the deep forest called the Dragon Mere and to the west the sea, and to the east another range of mountains, the Fenhair Spires. These people are among the most peaceful in the Empire, a nation of scholars, philosophers, poets, and mystics. Otherwise the entirety of the Confederacy is bad farmland, swamps, dangerous forests, arid grasslands, and sandy wastes.

As a result, on a regular basis, those living in the South find common cause to rise up and sack whatever defences the Empire has established in the gap between the Belt and the Clasp, often spilling into the rich farmlands north of the Girdle of Kesh. This is a region of constant strife, regular warfare, famine, plague, and hunger.

A MAP OF THE SO-CALLED KESHIAN CONFEDERACY, purchased from a mapseller in the city of Great Kesh. As many of the people living there are nomadic, the areas to the north are fluid and those in the south impossible to delineate.

And because a minor Prince gave orders in the city of Kesh, criers went out proclaiming that for those willing to leave their homes, rich, bountiful farmland, forests with game, rivers with fish, and abundance beyond imagining would be theirs for the taking should they be willing to leave their hardscrabble life in the Confederacy.

So, behind a screen of attacking armies, a flood of colonists arrived in Crydee, occupying farms, towns, fishing villages, and herders homes, as citizens of the duchy left before the attacking Keshian soldiers. The massive assault against positions throughout the Kingdom, coupled with threats against Roldem should she involve herself, the enemy's plans were unfolding.

The younger sons of Duke Henry of Crydee, Martin and Brendan, were forced to protect their duchy with barely adequate defenses, as their father had answered the Prince of Krondor's call for the Western Lords to gather against possible attacks on the Principality. As seems to be the nature of the conDoin family, like their famous ancestor, Prince Arutha, the three sons of Duke Henry, Henry (known as Hal), Martin, and Brendan filed reports that were brief to the point of being cryptic, modest to a fault, and lacking comprehensive detail.

What is known is that the Keshians landed in force, driving the townspeople into the Keep of Crydee or to the east. Some fled to the north, taking refuge with the elves in Elvandar, while others struck toward Yabon. Martin realized his position early on and engineered a brilliant retreat, costing the Keshian invaders both valuable time and more casualties than a less imaginative defense would have caused.

Reports I've read indicate that young Martin considered this a defeat, while every other source indicates he did the best possible job in protecting as many lives as he could, and that by the time he reached the city of Ylith, he was ready to take command of the tiny force there and, along with the men who had accompanied him, mount an effective defense of that city.

Politics being what it was, the city was finally saved by a truce between the two nations, but not until after grievous damage had been visited upon Crydee and portions of Yabon. Still, Martin and his brother were responsible for blunting a Keshian offensive that could have cut off Yabon from the Principality of Krondor.

The long-term impact of this incursion has not been evaluated, even now, after the truce. Hundreds, even thousands, of those who once lived in the Keshian Confederacy now occupied Crydee Town, and the farms, ranches, grazing meadows, and lumber and fishing villages from the border of Carse to the Elven Forest, from the ocean to Yabon. While this land may be recovered by the Kingdom in full someday, the impact of these new residents can only be speculated upon for the time being.

⚜ *So much attention was diverted to conflicts along the Far Coast, in the Sea of Kingdoms, and against the southern border of the Kingdom, little attention or note was given to the events in the Grey Towers. For it was at the site of the original Tsurani rift so many years before, where the fabric between universes had most constantly been frayed that the final attack was coming.*

Tyrone Hawkins and Henry conDoin Meet Lady Franziska

Entry, the Twenty-Third

I FIND MYSELF FLIPPING THROUGH THIS VOLUME *and while I am weary beyond telling, I also feel the need to comment on events since last I contributed to this work. Yet I almost do not know where to begin.*

This is the telling of a story that I do not wish to end.

I sit and gaze at this page and realize my mind still churns over the events I must relay. So much has changed in my world.

After my mother's and brother's deaths, my father went into a period of dark introspection, which was understandable, but one that also had serious ramifications for the Conclave. He abandoned Villa Beata, leaving it to become overgrown with weeds, thick with dust, and inhabited by vermin. His rationale was by doing so we would lull our enemies into thinking they had won, that we were defeated, while we scattered to a variety of locations and waited.

We were defeated.

Then came the events I last mentioned, the relocation of thousands of colonists by Kesh into Crydee as assaults were unleashed against the Kingdom and the effective quarantine of Roldem. It was perhaps not a coincidence that Father appeared to come out of his dark mood finally at the same time as the onslaught against the Kingdom began. Perhaps he felt our enemies had been lulled into thinking us no longer effective. I do not to this day know.

It is immaterial, for events overtook us before we had time to indulge in that sort of reflection.

The chaos that was unleashed by our enemies was to achieve one end, ensure that the attention of every nation was drawn away from locating their attempt to enter our world. That was the original valley where the Tsurani first invaded Midkemia.

In the valley where the Taredhel built their city of E'bar, treachery of the vilest stripe, breaking faith with one's own people, was in motion. For reasons that may never be known, for those who survived were not among the plotters and all that's left is speculation, the leader of the Star Elves, the Lord Regent himself, betrayed his nation to the Dread.

In an act of self-destruction that cost the traitors their lives, a fate too forgiving, a portal was opened into a dimension that was alien to anything experienced by even my father and me. A gateway was established allowing the very antithesis of life to come into our realm.

This was the goal of a plan put into play ages before my father had been born. For events carried us to places beyond our ability to fathom as we experienced events I scarcely believe myself, and I lived them.

There were two significant events, one well known, the other known to but a few, that also changed our circumstance. King Gregory of Isles died without a male heir. This set the stage for a full-blown civil war in the Kingdom, with several claimants to the throne.

The second event, not noticed save by a few, was the return of Nakor and my mother.

I should hasten to reassure you, the reader, they did not in fact return from the dead, but in as strange and unexpected a fashion as imaginable. Some agency, and even now after the fact I can only speculate who, conspired to visit two demons with the memories of my mother and Nakor.

How this was achieved remains a mystery. In our dealings with the gods, Father and I have encountered many strange and inexplicable events, including finding a Dasati in the Second Realm who had the memories of my grandfather, Macros. But at the time of meeting the two demons, Child, who bore the memories of my mother, and Belog, who now possessed Nakor's memories, both appeared exactly as we knew them in life. To say the first meeting was troubling is an understatement.

I may at some future date devote my energies to a detailed recounting of all the events and strange journeys associated with this period, as the two demons, my father, and I were propelled across space and time and forced to endure lessons by visions of people from our pasts before we returned to Midkemia to confront the menace that was now fully revealed to be the might of the Dread.

As much of this journal is concerned with the geography of Midkemia, I feel the need to add that my father and I discovered an island lying south of the Keshian Confederacy, home to an ancient race of Pantathians, but unlike any we had encountered over decades of conflict with them. These were a gentle and scholarly people, the antithesis of the evil masters of dark magic we had fought since Father first confronted the false Murmandamus.

This island was home to a community of well-tended farms and valleys with sheep and cattle, scattered orchards and fishing villages, and a lovely city with a peaceful population.

All of which was obliterated in a trap for my father and me.

In our travels, we learned the Dread was a collective conscious of an entity that manifested at the very first instant of creation, a being of power that sought to return the universe to the primal state in which it existed before creation.

Although that concept is difficult enough to contemplate, the next fact we learned was even more so; the entities we called the Dread were not many individuals, but one creature that spawned its aspects across space and time, simultaneously acting from its point of view at every moment and every place it chose.

Our one advantage appeared to be its inability to understand causality, that, to it, acts and results happened at the same instant, so that Murmandamus's plan to bring the Dread into Midkemia occurred at the same instant as the assault from the heart of the city of E'bar. Basically, it appeared that the Dread were doing everything possible that could be imagined because the Dread did not know what was working at any given instant in time.

I can do no better in explaining this alien consciousness, so I will leave it here: we endeavored to do all within our ability to prevent the utter destruction of everything we held dear, and more, for should the Dread prevail, all reality as we understood it would change so profoundly it can be said the universe as we knew it would cease to exist.

If I attempted to explain here every detail of that final encounter, the battle that saved this world, I would be writing for days, weeks perhaps, and still only bring the most superficial of understanding.

As the majority of this journal or chronicle, begun by my father, has concerned itself with the larger world of Midkemia, perhaps my best choice is to detail changes wrought by the unleashing of the terrible magic needed to save us all.

At the heart of the conflict, in the valley in the Grey Towers, a portal of energy, like a rift, was unleashed to usher the Dread into our world. The combined arts of elven spellcrafters, Moredhel shamen, human magician, and priests all contrived to take that energy and twist it into a confining dome of ruby red light, one that imprisoned the Dread for a time. When at last my father contrived a means of inverting that spell, using the enemy's own arts against them, the results were catastrophic.

An inversion of the very laws of nature occurred, and like a monstrous whirlpool, matter was sucked into a dark maw that was the passage between our realm and the realm from which the Dread originated.

Words fail me in describing what happened, in part because there was a period where I seemed to have lost consciousness; for one moment I saw the beginning of the destruction of the ruby dome, then the next I regained my wits literally miles away, as if I had been picked up by some giant hand and tossed to safety.

It's been a few months since those terrible events. Even yet we do not have a full accounting of those lost in the struggle. I can say with certainty that Father is dead.

Miranda and Nakor, or rather the two demons who shared a slice of their existence, have returned to the demon realm of the Fifth Circle. Tomas, Father's boyhood friend turned

Ashen-Shugar Metes Out Justice to Draken-Korin

Dragon Lord, was also lost and played a key role in our ... triumph is such a poor word in light of the destruction. Survival, perhaps better suits the reality.

Where the Grey Tower Mountains once reared to the skies, in their place is a crater, miles deep and easily two hundred miles or more across at the rim. Weeks after the destruction it roiled with dust, smoke, and wild magic. It is a pit of newly forming life, strange rends in the fabric of time and space that are spilling ... I know not what is down there. At some point in the future I will undertake an exploration of what is now being called the Sunken Lands, but for the time being I am content to leave that to the future. I still hurt too deeply over the loss of my father, and what feels like losing Mother and Nakor again.

I'm leaving Sorcerer's Isle for a while. I feel the need to travel a little, see what this unleashing of mad energies has done to this world. Agents from remote corners of the Empire and as far away as Novindus report changes, some trivial, others profound.

The school is in good hands. Ruffio is Father's designated heir in seeing to its daily operation, and of those magicians who survived the fight in the Grey Towers, young Simon is especially gifted. Amirantha has agreed to stay, for I think he at last feels here is a community to which he can belong. Surprisingly, the two Star Elf brothers, Gulamendis and Laromendis, have also requested they be permitted to abide for a while. Most of their kin have either settled in LaMut or traveled to Elvandar. The thought of elves who prefer to live in human cities is strange, but like many things, I expect I'll grow used to it.

My brother's foster children all managed to survive, thanks to Father's insistence they be tasked with duties far away. Jommy, Tad, and Zane will grow old and fat with their families.

We have a new King in Rillanon, Henry conDoin, a direct descendant of the first Duke of Crydee, and he has wed a Princess of Roldem, tying those two royal houses closer together. Not that either nation seems troubled by Kesh these days, as the disaster that befell E'bar and the Grey Towers seems to have had repercussions in the Empire as much as anywhere else in the land.

Most significant is the forest in northern Kesh known as the Green Reaches. It has changed into something alien and impossible to navigate. First reports are that trees are now packed so closely together that the old travel roads and paths are gone, and that strange plants now spring up among the familiar, things with vines that attack those who seek to enter the forest, thorns with unknown poisons, and strange animals never seen before. Whether this is the result of minor rifts allowing alien life forms to come to Midkemia or this is magic changing existing life, I do not know, but I will put this forest high on my list of places to visit.

I have reports that the forest around the Great Northern Mountains is likewise changed in noticeable ways. Our agents in Durbin are hearing reports of changes up in the Trollhome Mountains, where more strange creatures are seen wandering the peaks and in the alpine valleys, as if they had always been there. Large sheep with four horns, black wool, and red glowing eyes, as well as birds unseen before the destruction of the Grey Towers.

Herds of strange-looking animals have been seen roaming the plains to the west of the Dimwood, antelope with crimson fur, a bisonlike creature twice the size of a normal bull, and two-legged pack hunters that look like lizards.

Other reports indicate changes in the land near Opardum and the City of the Guardians in the Eastern Kingdoms, and subtle but noticeable ones in Rillanon, where flowers unseen before are blooming, and brightly colored birds, something like macaws or parrots yet not quite those birds, are nesting in trees around the King's palace.

With few left in the Confederacy, it's hard to credit reports that entirely new species of animals and plants abound everywhere, odd herds of tiny deer and black-furred cats with manes like lions.

The Sunken Lands, a preliminary survey. More to follow. —Magnus of Sorcerer's Isle

Likewise we hear that the escarpment in Wiñet, the upper plateau, has risen a hundred feet or more higher than its previous elevation, while much of the lower lands have been submerged in the sea, creating a series of isles and an archipelago.

The Sunset Islands have disappeared, with a terrible loss of life to those who lived there. Storms raged across the oceans for days as nature attempted to contain the unimaginable energies released by my father on that terrible day.

Of those who sought to protect this planet, half the magic users and clerics attempting to aid my father died instantly, and the remaining were driven mad or rendered senseless. If it weren't for those who remained at Stardock, refusing to aid my father, or those at the villa on Sorcerer's Isle he instructed to stay behind, I fear the population of magic users on our world would be even more endangered than it is now.

Of more mundane concerns, I can say this. The new King in Rillanon and his Queen, they are young, seemingly in love, and very happy. His brothers serve, with Prince Martin now installed in Krondor, and Brendan being named Duke of Krondor, to act as his brother's first adviser.

Jim Dasher has disappeared. He always claimed he someday would do so, preferably to an island where warm soft winds blew and the beaches were bathed by gentle waves. I suspect two things: if I need to find him, I will, and he has someone installed in Rillanon to take his place as head of the Kingdom's intelligence network. Given circumstances, I will wager that person is Tyron Hawkins, my old friend Tal's son. Jim thinks of himself as being very clever, which he is, but I've been watching Tal's family since the start and while I like Ty, he's just the sort of sneaky bastard Jim Dasher would choose. Besides, they seemed to

Triagia after the cataclysm. —Magnus of Sorcerer's Isle

always be in the same place at the same time when something critical was occurring. And, to tell the truth, the Conclave has its own spies out there spying on other spies.

I do not know for certain what it is I will do in the coming days. There is a great deal to see, and in the chaos that is following on the heels of the sealing of the rift used by the Dread, no doubt people are in need of a bit of magic help. I shall find them.

There is this one thing: if I fully understand what I have been shown, the lessons put before me, as harsh as they may have been, then I feel certain my father spent his life for a good cause. I believe that the menace of the Dread has ended, if not for all time, at least in a fashion that generations will come and go before anyone here, or anywhere else, need fear its return. If Tomas's sacrifice was not in vain, then the Dread is locked in a moment of time, in eternal struggle, with a foe that commands the Dread's entire focus and that moment stretches out across time and space in a way we humans will never fully understand.

In the end, I count the horrible sacrifices and terrible consequences well paid, and I weigh my own personal sorrow and sense of loss trivial compared to the greater good. This admission would cause my father a great deal of amusement.

He and I had words recently, as to the mounting sacrifice asked by the need to "do the right thing," as my father would have put it. He saw no cost too high or pain that could not be endured to act on behalf of others. He was the most selfless man I have ever known, with a commitment to caring for the well-being of others at any cost.

I have learned from my father. I hope I will someday be counted his equal, not just in the magic arts, but as a human being, as a man.

So where now? First I think I shall investigate the changes down in the Green Reaches, to see for myself what this mad release of magic around the world has begun. I shall pay my respects to the new King and Queen and shall venture across the seas. I shall poke around in the mountains of Novindus, to see if any hint of the Pantathians remains, and I shall visit

the Saaur up in Wiñet and make myself known to them as Pug's heir. My father gave them a pledge they would know peace on this world and I intend to keep this pledge.

I will try to repair what can be repaired, and I shall attempt to compensate others for their losses where I can. Avowing what was done was for noble causes is but one part of what my father taught me. Repaying those who had much taken away is another.

I shall spend some time in the South, in the Keshian Confederacy, seeing what the mix of shifting populations and wild magic has wrought there, and then I shall move along.

I will come back to Sorcerer's Isle and visit Stardock from time to time, simply to keep an eye on things, but trust in others to do important work while I travel and see this newly reformed world.

Perhaps I shall venture to visit the Moredhel in the Northlands and see how they fare. For most of my life they have been faceless enemies of man, yet the experience I had with them during the war with the Dread taught me they are a fierce, proud, and unique people, an honorable people.

Eventually I shall return to the crater called the Sunken Lands, to see what has happened at the heart of the changes on this world. I shall perhaps risk poking around down there should conditions permit.

And I shall eventually return to Crydee, my father's birthplace. I have not been there in years, and though it holds none of the special meaning for me that it did for my father, none of the close associations with childhood memories, it still holds a special place in my heart, for it was my father's first home.

It may be years before I finish all my travels, and I may be diverted along the way, but in the end I shall see everything I can, for this I know. Somehow my father conspired to keep me alive when I should by all rights have perished. My life is my father's gift to me, twice now, and I will not squander it.

It may be many years before I reach his boyhood home in Crydee, but I will eventually get there. I have more than enough time left before me.

— **Magnus of Sorcerer's Isle,**
Son of Pug

Acknowledgments

For this project especially, I wish to acknowledge the original Thursday/Friday Nighters. Among that group, Jon and Anita Everson, and their son Dan, contributed greatly to this project and deserve special mention. As for that core group of beer-drinking college know-it-alls: Dave Guinasso, Rich Spahl, April Apperson, Lorri and Jeff Velten, Ethan Munson, Tim LeSelle, Conan LaMont, Steve Barrett, Bob Potter, and everyone else who drifted into and out of the group. Without them, the world of Midkemia might have existed, but it would have been a shadow of what we present to you now. Midkemia developed as it did because several creative people kicked in their bit. Everything about Midkemia—its various cultures and politics and people—stems from discussions, arguments, practical jokes, and everything associated with the old-style paper-and-pencil role-playing games of the Thursday/Friday Nighters. Steve and I owe a debt of gratitude to this core group of Nighters. We may have been the main cooks in this, but you guys added the spice and the flavor.

And a special thanks to Signe Bergstrom at HarperCollins Publishers, MinaLima, and Steve Stone.

Raymond E. Feist
San Diego, California

I'd like to echo every word Ray wrote and additionally acknowledge my wife, Mary, who allowed me to concentrate on this project to the detriment of learning French for our vacation to Paris.

Steve Abrams
San Diego, California

II. (2) MIDKEMIA AFTER MAGICIAN'S END

South
Triagia

EQUATOR

The
Archipelago

The Havens

About the Authors

Raymond E. Feist was born in Los Angeles, California, at the end of World War II. His father, Raymond Elias Gonzales II, died when Feist was not quite five years old, and four years later his mother, Barbara, married Felix E. Feist, who adopted both Raymond and his younger brother, hence the name change. His stepfather died in 1965 and his mother in 2010, at the age of ninety-three.

Feist grew up in the San Fernando Valley and attended Birmingham High School in Van Nuys, California. From his high school graduation until 1980 he attended college intermittently, worked all manner of odd jobs, and traveled. While working in Jamestown, New York, in 1971, Feist undertook his first attempt at writing. After he lost a very good job due to a lack of a college degree, he returned to California to attend college. He matriculated first at Grossmont College and then the University of California–San Diego, where he earned his BA in communications arts with an emphasis in mass market and public opinion.

During this period he began writing again, and at the urging of friends, he finished his first novel, *Magician*. In 1980 the novel was published, signaling the beginning of a career that now spans more than thirty years.

Feist lives in San Diego with his college-age son, and has an older daughter who lives in Northern California. His chief interests are music, wine, single-malt Scotches, football of all types, film, the company of friends, and spending as much time as possible with smart and insanely beautiful women.

Stephen Abrams was born in 1951 in Fairfield, California. His father, a pilot in the air force, moved often, which resulted in Abrams's traveling extensively throughout the United States and Europe during his childhood. He later earned his master's degree from the University of California–San Diego. After working at the university for a couple years he decided that he'd rather be in the computer science field, and after some additional study he landed a job at the NCR Corporation, followed by Burroughs, Doric Scientific, and SofTech Microsystems. He then came to Cubic Defense Applications, where he's worked for the last twenty-nine years as a senior systems and software engineer.

Always an avid gamer, Abrams started participating in role-playing games in 1974, the same year Dungeons & Dragons was released in the original three-book set for miniatures. Soon he and his friends—a group of gamers aptly called the Thursday Nighters, and later the Friday Nighters, after the days of the week they met—created the Tome of Midkemia, a new set of gaming rules far more realistic than those of D&D. The world of Midkemia became the game environment. In order to game in Midkemia, each player had to contribute a dungeon, city, town, or country into the shared world. In 1979, Abrams and his good friend Jon Everson started Abrams and Everson (Midkemia Press), publishing game products.

Abrams lives in San Diego with his wife, Mary, and has three adult stepchildren who live in California and New York. His interests include sailing, sports cars, wine, single-malt Scotches, and computer gaming.

MIDKEMIA
THE CHRONICLES OF PUG

Copyright © 2013 Stephen Abrams and Raymond E. Feist
Illustrations by Steve Stone
Maps and decorative elements by MinaLima Design

All rights reserved. No part of this book may be used or reproduced in any manner whatsoever without written permission except in the case of brief quotations embodied in critical articles and reviews. For information address Harper Design, 10 East 53rd Street, New York, NY 10022.

HarperCollins books may be purchased for educational, business, or sales promotional use. For information please e-mail the Special Markets Department at SPsales@harpercollins.com.

First published in 2013 by
Harper Design
An Imprint of HarperCollins*Publishers*
10 East 53rd Street
New York, NY 10022
Tel: (212) 207–7000
Fax: (212) 207–7654
www.harpercollins.com
harperdesign@harpercollins.com

Distributed throughout the world by HarperCollins*Publishers*
10 East 53rd Street
New York, NY 10022
Fax: (212) 207–7654

Library of Congress Control Number: 2013940367
ISBN 978-0-38-097826-7

Printed in China
First Printing, 2013